MOUSSE PUBLISHING

kunstwegen

MANUEL *or*
A HINT OF EVIL

Armin Lorenz Gerold

From the perspective of ordinary affects, things like narrative and identity become tentative through forceful compositions of disparate and moving elements: the watching and waiting for an event to unfold, the details of scenes, the strange or predictable progression in which one thing leads to another, the still life that gives pause, the resonance that lingers, the lines along which signs rush and form relays, the layering of immanent experience, the dreams of rest or redemption or revenge. Forms of power and meaning become circuits lodged in singularities. They have to be followed through disparate scenes. They can gather themselves into what we think of as stories and selves.

Kathleen Stewart, *Ordinary Affects*, (Durham, NC and London: Duke University Press, 2007)

Contents

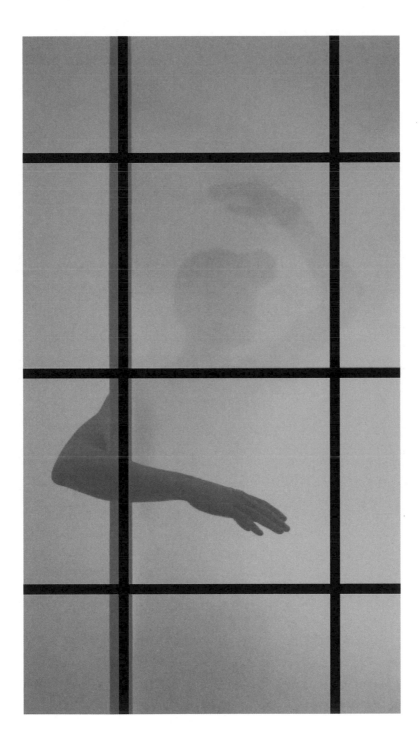

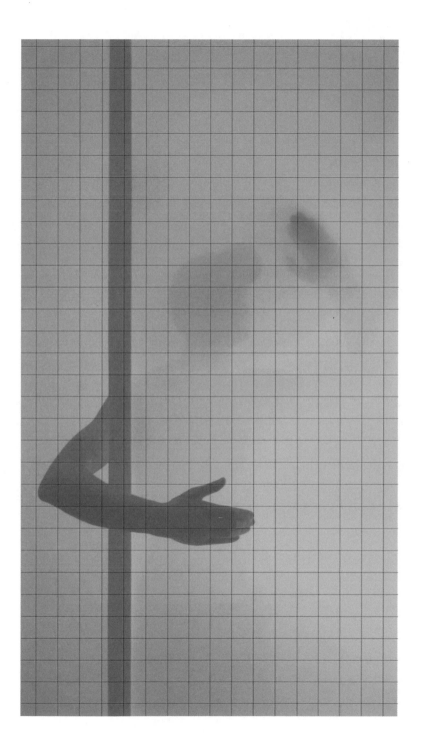

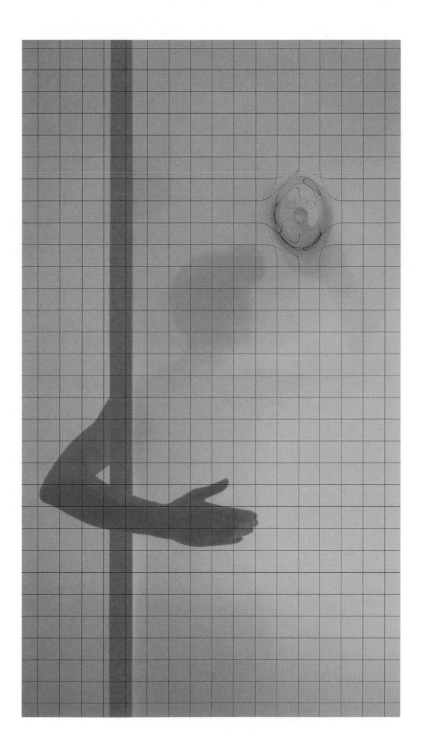

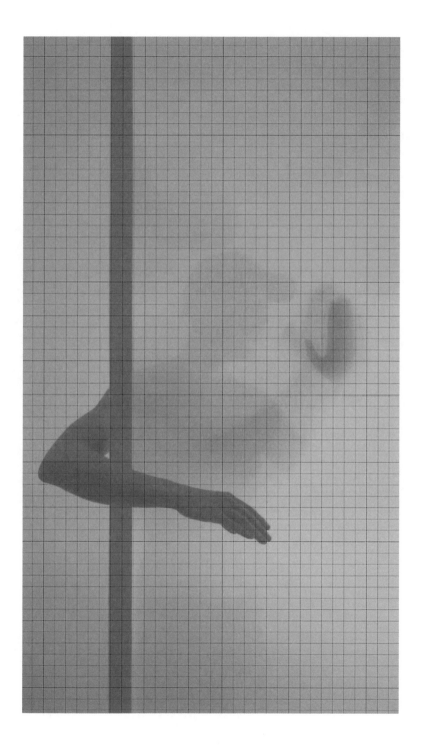

Preface
Shahin Zarinbal

This book is the product of a process – of incomplete processes; of an attempt to gain orientation in an increasingly disconnected and atomised social world. An attempt to search for closeness in strange souls, find distance in presence, and sense paths to other futures; to devise an exhibition that can exist as a plan, as material not fully assembled – as a model, as text, as sound, as a link, as a book, as a fully formed fragment.

In a way, the story of *Manuel* is the story of a failed flirt, and the power of the irrationality that holds sway over us the more we seek to eliminate it. The narrative unfolds from the perspective of an unnamed observer whose thoughts coalesce into an inner monologue as he makes regular visits to the Olympic swimming pool in West Berlin, in the summer of 2020. It is the story of urban bodies travelling across the city for a brief summer escape; the story of their sounds mixing in the hallway, showering, murmuring on patches of grass; of their arms and legs slashing through the water, forming rhythmic patterns that echo through Nazi architecture, and entering the mind of the listener as his gaze wanders across the pools, looking on.

Manuel is the story of desire gazing out into unknown territory. Queer desire has often been tied up with the question of space, questioning rigid and oppressive segmentations of private and public spaces and, even more importantly perhaps, embodying new variations of how to mark the distinction between public and private. In *Manuel*, Gerold also considers this distinction and the relationship between visibility and the privacy of desire, and how they might sound together at different volumes, when our shared reality is barely more than audible noise.

Sound, the medium around which Gerold's practice evolves, has the capacity to maintain a highly ambiguous relationship with its body, its place

of origin, inception and release, whether it's a biological or technical body, or both. Sounds, one might say, assert an identity and a disconnect at the same time. This seems particularly striking in the case of the human voice: each of us speaks in their own voice which, in order to be heard, must leave its body and create a bridge to someone else's. In metaphysical times, the human voice was thus regarded as the structure in which 'being' was preserved in its original form, pure presence. To create the world, God spoke.

The social theorist Niklas Luhmann differentiates, when it comes to communication, between information, message and understanding. We don't simply pass on information when we communicate; there's always a message involved too, one which may instruct, suggest, request, expect, want something in return. And there's understanding, the trickier part. It could be described as the decoding of information in relation to the perceived message, and the processing of this operation to further communication. Understanding is what must remain as opaque as possible in order for communication to flow.

So, understanding is that which happens silently, in the pauses between the words, in the breaths taken in between. Listening is a form of understanding, too. It is not passive perception; it is highly selective and arbitrary. When we listen, we pay attention; we dissect the words that we hear, their meanings, sensations, tone, ring and shape, internally, in our minds. We may notice the effect of specific sounds on our physical body. We may shiver, contract, wink or raise our brows. Listening connects to our rationality as much as it cultivates our emotional response to what or who we are listening to in a particular moment. It could be a person, it could be the city, it could be as plain as water.

When Gerold translates his listening experience into sounds and words, spoken or written, he lends a new body to the fleeting reverberations of audio that permeate the space. Sounding out the border between public and private, between the controlled and the transgressive, between involvement and distance, his approach is one of *approaching*. Often, it seems as though he is lowering the volume of external, dominating influences just to see their echoes flare up in fractured impressions of observed behaviour – in the disinterested gazes of disinterested others, in heightened body perceptions, in the difficulty to follow one's desire.

The narrator's transfixion on Manuel remains barely visible. Depending on the circumstances, the space between them seems empty, charged and imaginary. It is a space where memory listens to its memory of the other: a private, ahistorical environment in which Manuel's space is not questioned, as he enters a territory he had no idea he could be a part of.

Listening is a paradox, which requires distance as much as it requires the idea of closeness – perceptual proximity through fundamental remoteness. In *Manuel*, Armin Lorenz Gerold is interested in the potential this paradox can reveal: to create a sensual space in which the unknown territory could suddenly, once again, become more interesting than a map of worn-out paths.

Phone displaying: Minor White (1908–1976), *George Jack, San Francisco, July 15, 1949*
Princeton University Art Museum. The Minor White Archive, Princeton University Art Museum, bequest of Minor White © Trustees of Princeton University

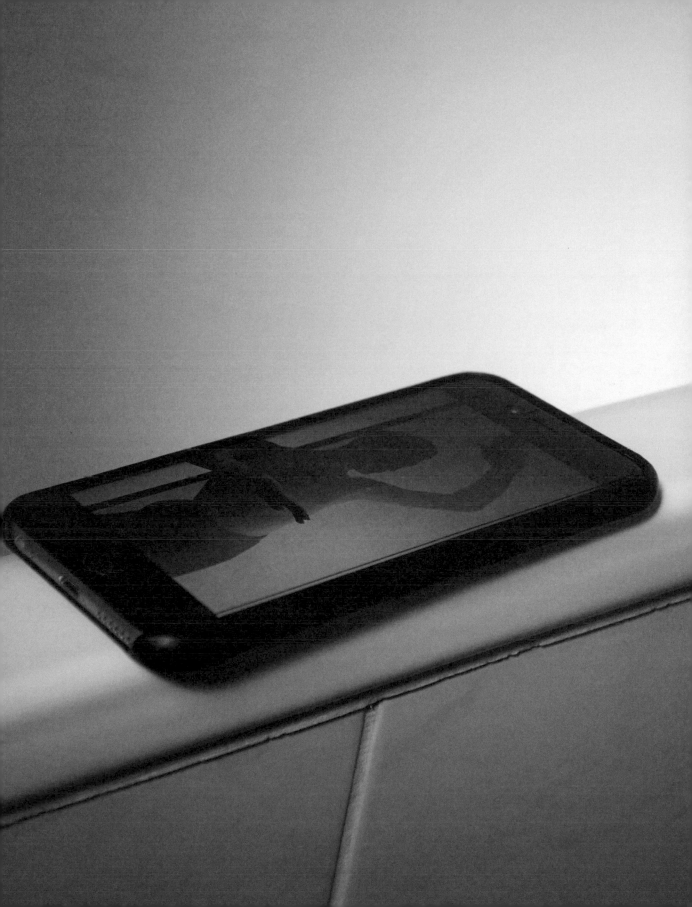

Digging a hole: a deep bass.

Alejandro Alonso Díaz

Defined as a sound vessel beyond human perception, Gjallarhorn represents the most idyllic instrument known to Norse mythology or, on the contrary,

a cautionary tale
mythical desire.
thought of
has been variously
horn" or the
as a locus tool,
sounds of upper
paradisiacal
Earth. The allegory
to its morphed
embracing the

of sonic space doomed by
Ancient Norse mythology
Gjallarhorn (a term that
rendered as the "hollering
"loud-sounding horn")
which brought together the
air, the domain of
lambency, and clammy
of Gjallarhorn corresponds
etymology [/ jal rhorn],
meaning of those who can

hear beyond their physical capacities. It invokes a space for those scourged by delirium or anxiety. In it, sound is viscous and desire ubiquitous. We dance within an architecture of desire. We obey its voice and enter the temple: a long corridor and a foggy sky. This convex place is a purely tactile dimension.

Silk, concrete and plastic are your new skin. Sound around, move around. Look at your back and then look at the ground you're stepping on. Go and dig a hole with your bare hands, feeling the deepest of sounds on your diaphragm. Your gaze gets lost in the fog. It is deeper and it is ecstasy. The senses suspended, desire blossoms.

A virile voice:

Do you hear the world while being in the world? Your limbs are entangled within it, not somehow outside – not above it, or looking in. The individual does not expand beyond the body, the body unfolds the individual. And if meaning and

feeling inhabit that fleshy space, let the individual's compounds sound together. A sonic body precedes perception: the listening process is only an encounter. Desire has already been fed; the distance has already been bridged. And now, what are the sentient substances of sounding beyond the self? Beyond us?

To receive sound without desire seems perceptually awkward: it does not lend itself to an experience of spatial projection, but the experience of longing. Sound traverses the space between a vibrant object and a listener just as readily as desire does between the smell of bodies. Although the reverberation of sound is not comparable to a phenomenon that might elicit desire, its vibrations carry the impulse of sensuality from within to outside our bodies. The sonic sensual is a constancy of action, it is the result of a vibrant state of matter. Sounds like magnetic attraction.

Dancing in the temple is like praying. Our consciousness is suspended and we connect through flesh, like a chemical symphony. Goosebumps, sweat; our hearts beating at a tuned rhythm. We go on and move closer towards the fertile garden. The smoke is a fog that allows the plastic figures to sway, gently taking in our movement. "You are sitting and smoking; you believe that you are sitting in your pipe, and that your pipe is smoking you; you are exhaling yourself in bluish clouds."[1] You smell like sex and try to carve another hole. You bury the sound of our words. A virile voice: an empty profound bass. Soon it will root. Your movement intensifies. Your movement as a labyrinth revolving around itself; it is a ritual of transformation. Just as sound transforms into movement, we melt into each other. Look at your bare hands again, vibrating to the rhythm of this temple. You touch the walls; it is important to train the skin to the surface of things.

Terrestrially, sound is not only experienced as a floating event but as a vibrant force surrounding our bodies. As we move, the aural presence of its force becomes matter. It is an oscillation of existences. "First you lend the tree your passions, your desires or your melancholy; its sighs and its oscillations become yours and soon you are the tree."[2] The lower, most profound sounds, for instance, can be heard coming out from the soil going up to the nape. You can feel them from behind and, as this feeling intensifies, it can be felt on and within the body as a whole,

dislocating the frontal and lateral perception of space, blurring your vision until you can hear everything by way of an all-encompassing spatial and corporeal perception.

A thousand sonic waves cross through our bodies as we float. Now we turn our bodies towards each other, just like sunflowers rotating towards our respective suns. But the sound is dismembered and we expand in multiple directions. We dance like luminescent, shifting bodies, like toxic reflections on a contaminated river. We vibrate translucently, soft and brittle. Skin as smooth as opal. You look at my solarised body trying to grasp it across this electromagnetic fog that enfold us. The sound of a bell. You see me you me you me you me you me you, in this cyclical geometry.

Given the volatile and evanescent nature of sound, perception and desire are a single spirit untethered, where glistening bodies and forms prove the most dynamic materials.

Complex geometries and shapes emerge from vibrant encounters and angles that have sounded and 'become' us since the dawn of the universe. Slowly moving surfaces exhale the dust of sound in myriad ways, the way nacre changes colour with variations of light. Its metamorphosis becomes our mathematical desire.

Is the contact between our flesh a sonic manifestation too?

1 Charles Baudelaire, *Artificial Paradise*. (New York: Herder and Herder, 1971), part 1, sonnet 1.
2 Ibid.

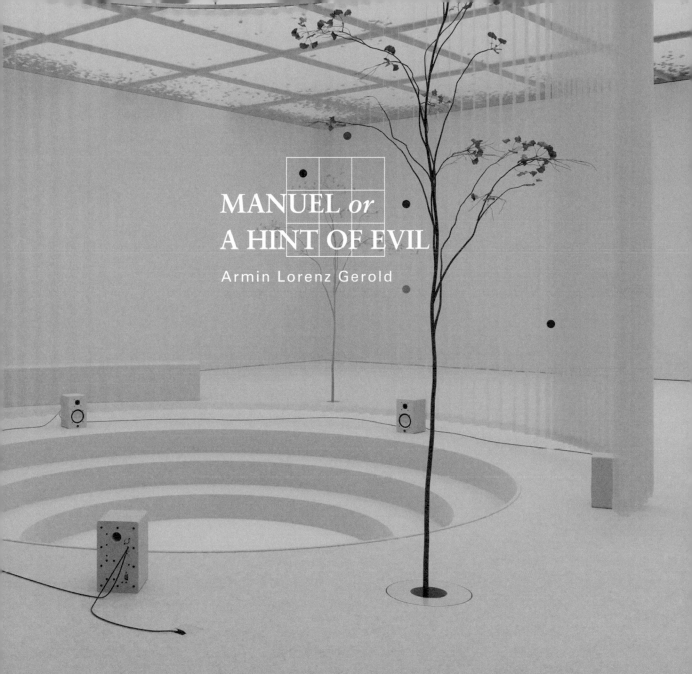

MANUEL *or* A HINT OF EVIL

Armin Lorenz Gerold

Manuel or A Hint of Evil is the fourth in a series of audio plays on sound, location and queer readings of space. have been presented in exhibition settings, as live performances, radio broadcasts, and on CD. This is a text version of *Manuel.* Find a QR code on the back of the book to listen to the play.

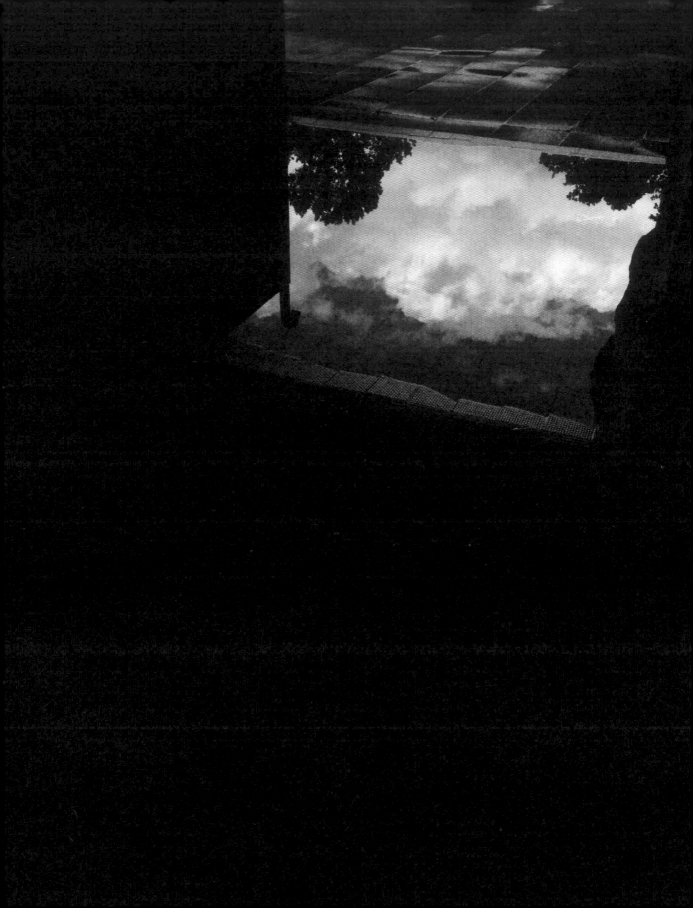

Negative space

He walks down the path that winds along the south side of the stadium. On the opposite side, a porous stone wall topped with a fence delineates the path's edge. Beyond it, he can see a kind of back yard, where scattered work equipment shrinks into sprawling vegetation. As he contends with the direct sunlight, his gaze falls on a series of leaden, athletic-looking sculptures. They barely stand out because of the distance, and appear to merge with the stone wall itself, which is only a few shades darker than they are.

What we see looks back at us.

He notices a group of men walking towards the pool. They almost seem to be walking in step, their bathing shoes lightly tapping the pitted asphalt. The sound mingles with the memory of a demonstration last week, in which he was walking alongside a line of police officers down a cordoned-off street. He walked carefully, but without an actual destination, or a voice that would navigate the event. Only a few placards and scattered, sparse chants suggested outrage over the events of the past few weeks, which had led to reports suggesting an escalation in racist police violence. Visibly tense after weeks of isolation, people eyed each other skeptically, and moved more or less woodenly with the flow. With each spontaneous influx of new demonstrators, the rhythm faltered again. Up until that point, he had only had a vague awareness, a creeping sense of how the negative space between people could suddenly and mechanically dictate their flow. Like a kind of magical thinking that sought to locate a gap between them, a suggestion of evil.

Immersed in the sound of shoes trotting along, in which he can barely distinguish his own from the others', the path dissolves into a small forecourt. On either side, rusty old garage doors seem to both reflect and retain the midday heat, and he feels as if he is entering a different space.

At the end of the small forecourt is a bare marble passageway, whose high ceilings, desolate, unoccupied windows and old signs all foreshadow the building that leads around the stadium. The increasingly loud, echoing shouts of children penetrate through the passageway, and mix with the monotonous clatter of sandals. The sounds converge in his head, seemingly coated by the dark sheen of the place, and the children's laughter gradually morphs into a set of ghostly reverberations. He stops at what resembles a small aisle: there is a pool of water, ankle-deep, which he must cross to reach the bathroom. He wades gently through the murky liquid, and his gaze falls on the reflection of the stadium it discloses: an unseen perspective. He lingers for a moment, studying it, until a man approaches from behind and stomps through, churning up the water in brash ripples that break up the clean picture on the surface. He dismisses the observation and surrenders to the sense of impenetrability there is about the place, which only ever reveals fractions of its architecture. The sight lines that converge now and again in superhumanly large squares and lofty constructions have a habit of making one feel small, and intimidated. But from certain perspectives they seem like afterthoughts: attachments, or auxiliary constructions that seem imprecise, cobbled together, or somehow hollow.

Floating bodies

It's a clear day in July. He looks at the small pool beyond the big one, which is far too narrow for real swimming and serves only as an overflow basin for the divers.

Red tape blocks the metal ladder that runs up the side of the diving tower and rises above it. The top of the ladder provides a view of the stadium on its southern side, as well as of the street lying slightly below the wall. But the street can really only be glimpsed by a group of people whose heads rise above the wall,

and who barely differ in size from the sculptures scattered along it, the two seeming to blend together.

An elderly woman draws slow elegant breaststrokes, out of which several lines on the surface of the water jerkily emerge. Water sloshes to the edges on either side of the pool, then disappears into a plastic grid. He almost doesn't notice the man a few metres in front of him, in the corner of the pool. With his shoulders still out of the water, the man takes a careful, silent step back, briefly gliding on the ripples, floating free for just an instant, before returning to the small step that had been his support.

He thinks he can discern some small excitement in the man's half-shaded profile: a sensation, an almost childlike curiosity about this procedure and its repetition, which somehow seems to contradict his muscular body.

He looks over the expansive biceps, the shoulders and neck, around which is a gold chain that has now settled into a strange bow, and which the water presses against the man's neck. The man looks up at him, turning his head back slightly, as he is now almost beyond him. The man doesn't smile but looks back serenely, as if his mind were completely immersed in water, undisturbed by the cautiously curious gaze.

He has to focus on not turning around as he makes his way to the big pool, so filled is he with the gentleness of the game.

Manuel, he thinks or says. Manuel.

In the second of four lanes, where two are reserved for fast swimmers, he discovers a small gap between people that allows him to swim the first lengths in front crawl, a discipline he learned only in the early part of the summer, and which is still a little foreign to him. Even though crawl strokes now tire him less, have become increasingly intuitive movements for his body, they still require a lot of mental effort. This is why his thoughts often seem choppy and disjointed as he swims, so that sometimes, standing at the edge of the pool at the end of his workout, panting, he doesn't know if he's done any thinking at all. It's as if he's looking at a pile of notes he's made during a phone call, in which lines and areas reflect certain stimuli, but no discernible meaning.

He now moves effortlessly up and down the pool for several hundred metres, a quantity which, when divided into segments, seems to recede into ever greater distance. A few times he becomes aware of other swimmers aggressively trying to pass him, coming much too close; he will suddenly feel his hand brush the space left by a kicking foot, but without the two actually touching, like a phantom pain. But it doesn't discourage him, and he keeps up his speed in spite of the crowds of swimmers. On other days he had stopped for the same reason; or sat on the edge of the pool for a while, unable to stand how some took the space for themselves – almost always men – and moved through the pool indifferent to what was happening around them and the physical abilities of other swimmers.

So it could happen that while swimming he would see some body part approaching him, as if in slow motion. In the midst of the crawl he would turn his head, and while catching his breath, notice the flushed water slap against the cheeks of another head, in another lane to one side, which would then tumble in its turn, having to pause briefly before swimming on.

In the moment you learn something new, he thinks – in the anticipation of effort and repetitive failure that instills something physical in you, but before it is formed as an experience – there is a thoughtful silence; a loneliness that subsides again almost unnoticed, as the horizon that once lay only in the unreachable distance gradually becomes more tangible.

The direct sunlight draws a sharp edge through the waters. The shadow of the grandstand settles over them, wrapping the pool in a uniform blue. As he surfaces and feels the warmth of the sun, he sees a body some way off, pedalling almost upright through the water. He raises his head as far as he can and recognises the man from before, deliberate and strained, struggling through the water, movement by movement, and he's almost embarrassed at the sight of the athlete wading his way like a puppy towards an unknown target.

He puts his concentration and effort to one side, and pulls himself out of the pool, resting his backside on the edge; and from there he watches the stranger for a little while longer.

Dreams that report

A day in August. He rides his bike through the city, in a hurry, running late for the short window of time he has booked in for the day. He feels as if he's dragging something behind him, as he makes his way through the narrow streets on the city's western side. The route he is taking he sounded out gradually, curve by curve, until a course had slowly established itself in his mind's eye, one he was satisfied would prove as scenic as it would efficient.

He remembered the day he had taken a friend to the pool with him, who had painstakingly followed him on his bike. He, meanwhile, had a slight temperature and was absolutely exhausted from the long walk to the West End. For weeks he had remained rather secretive about his newfound swimming habit, all the while overemphasising its regularity to himself, as if to remain properly motivated by the thought. He had also made every effort to ensure that there was no doubt among his circle of friends that he knew the way to the West End by heart. But after the big roundabout – still a few kilometres from the stadium – he had become puzzled and turned into a street which, according to its own name, followed the Olympic Marathon route – the 'Olympic Marathon Way'. His thoughts circled over the city; he couldn't stop retracing the 42.6 kilometres, but his calculations faltered. He was no longer sure whether the Marathon Way was only a symbolic artery dedicated to its historical predecessor, or whether it actually ran through the entire city.

He grew tired of thinking about it, although he had to admit that when compared to his calculations, the road carved out a bend that was much too pronounced, and the destination he had promised seemed to recede further and further into the distance.

A few comments from the increasingly powerless, bemused friend had renewed his energy. He spun off into a story about a 1960s urban development programme, to distract from the fact that he didn't know exactly where he was. At times he would succumb to the pull of his own persistence in this way – and as little beads of sweat had trickled down his shoulders into the hollow space between the curved cross and his backpack, his eyes had clouded over at the thought that he was normally good at understanding directions – and he had felt ashamed.

Stereo is a binary model.

In the forecourt he takes a quick, ice-cold shower, and then walks past the large pool to the small concrete benches beyond, where the terraces are cleared for bathers and offer a good view.

Manuel. His gaze meets Manuel's, who is standing in the water, his eyes only slightly averted. His athletic back rises out of the pool and his necklace sparkles in the angular light of a brooding sun. Another man is standing by the cordoned-off diving towers, crouching down and talking to Manuel with one of his legs outstretched, as if trying to achieve some therapeutic benefit from the position.

At the sight of that straight back a fleeting, phantom pain runs through him. He is somewhat relieved. He wouldn't have the energy for conversation today, and he wouldn't want to give his new acquaintance any less attention than would be appropriate. Recent conversations had generally contained little that was new and – particularly in the light of the strange time that was now dragging on, pervading every instant – they increasingly resembled another form of coping mechanism. So little that is new and spontaneous mingles with the few words people exchange, he thinks, and so he doesn't struggle for a moment with the decision not to greet Manuel, and seeks out a space on the concrete, where there is enough distance between people. In the semicircular opening at the end of the stands, he struggles for a while with the panoptic architectural form he's faced with. The shape of it makes the bathers beside him appear closer than they might on a less defined surface, like a vale, a meadow, or even just a patch of grass.

He settles down to read. Intermittently, the sounds of a conversation between two women nearby, whispering to each other side by side about their periods, interrupt the stream of his thoughts, intruding on his reading of *The Third Reich of Dreams* by Charlotte Beradt. Sometimes, these incursions are so abrupt he has to raise his head to check the distance between the women and him: their voices break impetuously into his space, amplified by the architecture and engulfed in the piercing sounds of children, which shoot wildly back and forth across the concrete like arrows.

It had always seemed paradoxical to him how the sound of whispering could suggest discretion, and yet at the same time, almost instantly and imperceptibly, activate the attention of those in the vicinity. Snatches of talk continue

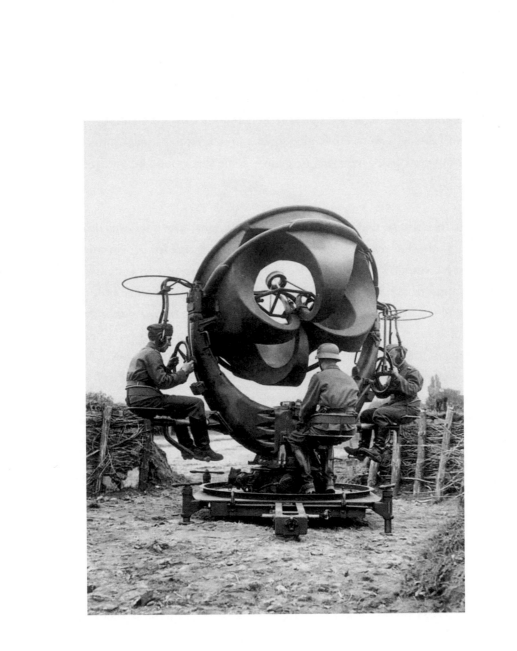

Berlin flak listening device, Eisenhardt, 1939 (Photo: German Federal Archive)

to mingle in his head, weaving in between the lines of the book in which he is reading about the dreams of Germans in the years prior to the Second World War.

Up until her expulsion from Germany, the Jewish journalist Charlotte Beradt had recorded and written down the dreams of more than 300 fellow Germans; and she had despatched them abroad, in an attempt to outline what kind of regime was in the making, mapping out, in some ways, how the Nazis' total surveillance of people extended to the very depths of their subconscious.

Most of the books he had read dealing with the Nazi regime seemed to follow the logic that inconceivable horror could be countered with some form of rational evidence; they did so almost by force. So his heart throbbed when it was faced with Beradt's audacious attempt: to look for evidence in the nocturnal visions of her fellow human beings as proof of what people already knew, before it had happened. Dreams that do not ask for explanation; dreams that report.

Having almost forgotten the purpose of his visit, and having absorbed so much heat, his body now sits on the edge of the pool. He slides into the water in one motion, dives up and down a few times below the surface until finally, without looking, his toes come to rest on the small ledge that lines the wall of the pool, drifting almost to a stop and yet allowing himself to sway with the water. Then he takes a deep breath, sinks below the surface into a crouch and pushes himself off the wall, swimming a few strokes underwater, hardly noticing how the outlines of other bodies are imprinted on the bottom by the sunlight. He thinks of one of the dreams described in the book: that of a young woman who, after pouring out lead on the New Year's Eve of 1933 to 1934, had dreamt a series of pure impressions, rather than situations.

Am going to bury myself in lead. Tongue is already leaden, locked in lead. Will lie immobile, shot full of lead. When they come, I'll say "The leaden cannot rise up." Oh! They want to throw me in the water because I'm so leaden..." [1]

He turns in the water now and looks up at the other bodies from below: they seem to flow through the pool the way brushstrokes are framed in a painting.

[1] Charlotte Beradt, *The Third Reich of Dreams.* (Chicago: Quadrangle Books, 1968).

He squeezes the last of the air in his lungs through his nose and, almost unable to control it, floats back to the surface. He takes a deep breath, but the pressure escapes only physically; it will accompany him for the rest of the day, pushing itself now and then between time and experience, like something he drags behind him.

Inaudible conversation

He watches the surface of the water, studying the reflection of his outline as it floats before him, gently silhouetted by the ripples and yet stranded there, as if some more permanent image might only emerge later.

He lingers in this tension for a while, when suddenly another contour appears, penetrating the pale shimmering, the flickering undulations of his reflected body. He straightens up and recognises Manuel standing beside him.

He stares into the bluish, almost lifeless area that glows under Manuel's eyes, before allowing his gaze to wander down over the slightly open mouth, become entangled with the gold chain below it, and latch onto the pendant that sparkles lower still, above the not-quite-shaven and jagged pattern of his chest hair.

The two men sit stiffly beside one another at the edge of the pool, between sun and water. And it takes time for him to let an initially invasive closeness – the menace of the circumstances – to slowly dissipate.

Their conversation ripples along clumsily, and just as the questions turn to glances, then pauses, careful and curiously musing, so he has to remind himself that he doesn't actually know this stranger who suddenly seems so familiar. Their bodies, turned towards each other, barely move – until Manuel grasps his hand and turns his wrist to look at the watch on it more closely. He recoils, briefly, when it glints in the light, but then becomes very gentle. The shadow of the grandstand rising up beside them draws a sharp-edged, dark surface in front of it. Slowly, it moves over: first across the surface of the water, then over their two bodies; and later, illuminated only by incidental and refracted light, they disappear almost completely in the late afternoon's hazy blue.

The concrete melody of their conversation, whose arrhythmic, uneven flow sometimes demands silence, is overlaid by the sounds around them: a mixture of water lapping at edges, amplified now and then by unauthorised jumps into the pool, and a multitude of voices flowing together at various volumes, like individual hairs accumulating under a carpet, growing into its surface.

Despite the raucous soundtrack, he notices how quiet the space has actually become. His pulse has slowed, and he doesn't feel it until a voice pierces through the speakers. Within a few seconds the hours have fizzled out, and they both get to their feet, smile, and start walking.

Janus

Another day in August.

It's early in the morning. He tips a drop of UHT milk into a mug almost overflowing with coffee, which the woman behind the small kiosk has just handed to him. The liquid turns a brownish grey.

The assortment of products has recently been cut back to a very limited selection. He wonders whether this really has anything to do with the pool's reduced operating capacity or can really only be attributed to the kiosk woman's irritability, and her desire to fend off any requests.

He drifts away from the counter and makes his way down the hallway, jolting a little as he walks between its porous marble walls. He is wary of entering any of the small alcoves moulded into it on either side. Though they are not explicitly cordoned off, he has the sense that they are observed, watched over, and silently rendered inaccessible by the custodial staff.

A dialogue takes shape in his head about a phone call with his father earlier in the day, for which he'd gotten off his bike and walked for several kilometres, pushing the bike in front of him.

The conversation had begun unremarkably – they had kept in touch more

of late, heard each other's voice more often – but the conversation had suddenly tilted when he'd asked his father what he thought of the protests that had broken out everywhere, against the measures announced by governments to fight the pandemic. He had wanted to get some unbiased reassurance, but his father had given strange half-answers, ambivalently positioning himself neither for nor against the issue.

He had felt his father suddenly shift, and turn, Janus-faced, across his inner eye. The older man vacillated, tried to remain diplomatic, contradicted himself; he cited dubious conversations with acquaintances about whom he knew nothing in detail.

He remembered having had numerous conversations of this kind with his father, but he had always felt that with enough time he could refute individual views – which had sometimes already become accusatory – and release the tension from the discussion with practical examples. He had always given his father a lot of space; and when it came to controversial questions time would often catch up with the older man anyway; it would teach him to be better, and what had previously seemed so regressive about him would ultimately settle down.

But this time he could not infer where his father's thoughts came from. He had gone through every channel his father usually adopted, every style of argument, gradually despairing that the older man had long since stopped listening. He'd ended the conversation – abruptly, on an impulse – something he never normally did.

When he reaches the end of the hallway he steps across the grass verge. As he does so, he pours out the contents of the untouched coffee onto the bare lawn, watches them settle into a motionless, stagnant puddle. He then plods back over the rough concrete to the swimming pool, where he sits down at the edge and watches the few swimmers go about their exercise. He fumbles through his memory in order to compile a kind of inventory of the conversations he's had with his father, pulling out individual scraps of words, tapping and contemplating them, holding them up to the light.

His physical distance from people now almost makes them seem one-dimensional. And then a man suddenly hoists himself out of the water, much too close to him, and wanders over to dry land.

Burning sky

Another day in late summer.

It has gotten colder and fewer people populate the narrow walkways around the swimming pool. Most are in the water, braving the weather to squeeze some exercise out of the day. He is sat down by a locker under one of the covered walkways, getting undressed. Unnecessarily considerate, his movements verging on awkward, his gaze sweeps the pool that is embedded in the floor in front of him. He carefully counts the number of bodies, making notes on each, head by head, as they protrude from the water. A dozen or so swim past. Perplexed by the count, he wraps the towel around his waist and slips on his synthetic swim trunks underneath – a balancing act on one leg, which almost causes him to fall over.

An instinct overcomes him: Manuel is not here. As if to internalise this feeling, his movements quicken, and it is only a few moments before he slides into the cold chlorinated water. His body feels weak, and he struggles to find the right speed in one of the lanes.

The usually aggressive swimmers are less of a concern to him today: only one pair come to his attention, a slightly older man and a younger woman, who weave and dive between the rows of swimmers. They're both wearing fins, glaring green as they pass sleekly and sharply in front of him. He glances at the next swimmer looming behind, but it does not make him either stop or turn back, and he surrenders to the monotony of his cradling arms and kicking feet for some time.

He hardly notices how the masses of water are less and less disturbed by movement, or how the lanes have emptied out. Small raindrops begin to strike the surface of the water, and as the interval between the individual drops shortens, a low, continuous murmur settles over the voluminous sound of his swimming. He comes to the centre of the pool and lifts his head out of the water.

A dramatically cloudy sky is taking shape above the stands and their wooden benches around the pool. His gaze rises up over the rows of seating to the right, estimating the distance to the weather front moving towards them like a blade sharpening its edge. He thinks he's safe for a moment or two longer, when

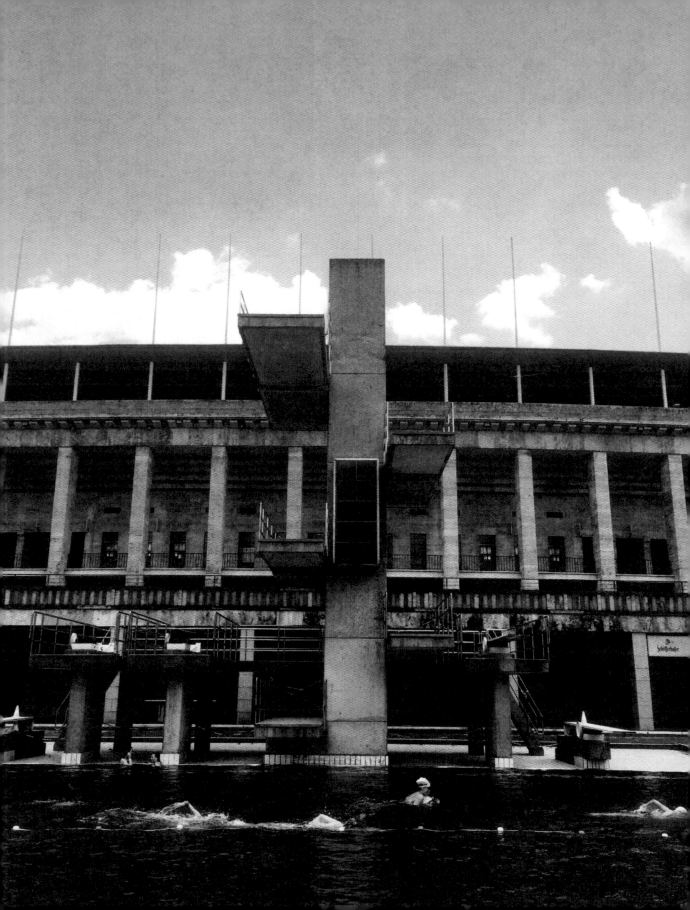

he sees only greyish-white sky directly above him, and subtle raindrops tap on his swimming goggles. The goggles gradually cloud over too, until finally he pulls them off to see a man at the edge of the pool making wild hand gestures, seemingly calling for people to vacate. One by one, the swimmers follow his instructions.

Only he takes a particularly long time. He assumes the attitude and posture of a very deliberate swimmer: one who, while signalling that they will obey the call, linger nonetheless in the magical sequence they have established. He sees the sky glow orange in the water's reflection; he sees raindrops fall and pierce the surface, and small, concentric rings extend their embraces to the whole pool. For one fleeting moment, it appears as though sky and earth are tipping into one another, and he is briefly disorientated among these gliding, watery rotations.

The swimmers who have not managed to escape the approaching storm come together under the canopy to one side of the pool. A few seem to know each other and fall into animated talk, until a voice echoes through a loudspeaker, across the forecourt and down the hallways. But what is being said is barely intelligible amid the layers of repetition: it warns the group to stay out of the water until further notice.

Beside him he notices an athletic young man who caught his eye earlier. He scrutinises the gently contrasting areas of muscle, lingers briefly on the man's neck and its conspicuously low-set hairline. He briefly attempts to make eye contact, but the young man seems to avoid it. Instead, he scans his own body, unimpressed, and seemingly irritated by the luminous sky above. He considers each muscle group in turn, now and then rubbing a spot with his finger, as if looking for scratches on the body of a car.

He had never understood this non-look from some heterosexual men. Non-gazes, impenetrable and almost frightening. He thinks that he could pay attention to almost anyone, by contrast. Even when consciously disengaged he often felt more preoccupied with feigning disinterest than being truly disinterested. As a result, he rarely moved freely through public space, and it was only in recent years that he had learned to give his own feelings adequate room, curb his almost seismographic reactivity. So he was all the more fascinated by this strange non-looking: he could discern nothing more than intention in it, and this thought had often annoyed him. The roots of his own behaviour he had traced to his

homosexuality, which had been with him in outdoor environments since he was very young and which was reflected, he thought, in his walk and how he measured his sensations by the glances of others.

Looking deeper into the dramatic sky, he notices a woman whose mind seems similarly moved. Their eyes briefly meet, but she too turns away from him and stares into the orange.

Disinfection

A day in September. He walks over to the bathrooms at the back of the stands. From inside he's unable to keep a watchful eye on the backpack he's left sitting unobserved by a bench. Who would steal during a pandemic?

But as he rounds the corner he regrets not having stored it in a locker. He stands at one of eight urinals – all the others are cordoned off – and realises that the disinfectant coming off all of the surfaces is starting to makes his eyes burn.

Behind him he hears someone set a bag down in the vestibule and then pass through the narrow corridor. He recognises Manuel before he has even seen the figure in its entirety. He feels his throat tighten, and then utter a short, impulsive hi, which Manuel returns without hesitation. He examines the familiar bushy eyebrows, then suddenly jerks his head away, adjusting his line of sight so as to observe Manuel's movements only peripherally. After a moment or two he slowly turns his head again, this time to meet the gaze that's now staring at him full in the face, eyes wide open. The tension suddenly lifts from his body and he turns to face him – only for a member of the cleaning staff to enter the room, put down a bucket and slap a mop on the floor.

The smell of disinfectant burns through his nose. Manuel walks past him, and all he can see is a blurry shadow moving against harsh, angular light. Meanwhile the cleaner tips the contents of the bucket over the tiled floor, as if he had never noticed another presence at all.

He pulls up his trunks and runs out into the hallway, but Manuel is already gone.

Signals

He regains his senses in the approaching darkness. Raising his eyes from the pages of his book, he notices the colours changing around him.

From the stadium's low outer wall he looks back over his shoulder at the outline of the building. It looms large in the blue-black sky, which grows paler as it falls towards the horizon, interspersed with orange-grey streaks. The memory of what he has read and of the past few hours fizzles out, and in its place he discerns a vague inner nervousness.

He grabs his backpack, damp from the towel inside, and puts it in his bike basket before setting off. After letting himself freewheel for a while, he starts to pedal harder so as to build up enough momentum for the hill ahead, and after the small bridge the resistance increases again. Shadows start to appear alongside him at regular intervals along the road, and it takes him a few moments to recognise himself. As he rides they extend, grow blurry and then finally dissolve, before reappearing again a few metres on. Physically he feels absent somehow, despite being involved in the mechanical process of cycling. He's still caught up in the upward and downward motions of water – the way one feels after days at the seaside, when we can still feel phantom waves roll beneath us even as we lie in bed late at night. Even the memory of Manuel's presence has not faded entirely. Somewhere below the droning, imaginary pressure of the water is a vanishing point, and he finds himself being sucked in.

Anxious, he gets off his bike to push it for a while until he reaches a fence, and the edge of a property. From the silence of the suburban landscape comes a dull, monotonous sound, as if someone were repeatedly banging a glass bottle against a solid surface. His eyes drift down the street, passing over a small opening towards a vacant lot, but he sees no evidence of what is happening. The muffled pinging slips into his ears, gentle and well-balanced. He catches himself thinking that he might attribute no further meaning to this alarm beyond the sound itself, and almost smiles – as if after all these years spent in the city he had become accustomed to its nervous skeleton, to the almost schizophrenic coexistence of the most diverse people, and how it produced this gradually learned indifference.

He thinks of the two men who built themselves a makeshift sleeping area two houses away from the supermarket, towards the end of November. They had used two mattresses and dozens of objects strewn all over the pavement, and since then had been lying next to each other drunk, engaging in fierce debate almost every night, with an old pocket radio blaring out Russian dance music as they spoke. No neighbours had ever tried to intervene, and he had rarely seen passersby attempt to strike up a conversation with the men, perhaps concerned at the cold weather. An ambulance might pick them up an hour later, only for them to be returned to their camp the following day when, at the appointed hour, the nightly scene would be replayed, and he would watch it from the open window of his bathroom, after his shower, with fresh steam floating up into the city air.

Calmer now, he continues his attempts to locate the sound. His gaze wanders through the darkness as if detached from his body – as if his eyes are searching for what he has heard. Puzzled, he pauses for a moment, discards the signals, shuffles back and forth. He ventures a few metres further, but the sound gets neither louder nor quieter; nothing emerges from the night. The darkness is succeeded by only more darkness.

The intervals at which the presumed glass body meets the hard surface increase, and eventually the sound dies away. But beyond this silence the movement of water returns, together with the memory of Manuel.

He closes his eyes and sees the small pendant swinging on the gold chain. Carefully guided by its owner's movements it spins on its axis, picking up the light and piercing the eye until nothing remains but the sound of water.

Ruisdael installation
Armin Lorenz Gerold

5.1 surround sound installation, approximately 41 minutes
HD video, sound-absorbing transparent curtain installation
Reflecting pond, carpets, assorted plants, Gingko leaves

Development and concept by Armin Lorenz Gerold
3D renderings by Stefanie Schwarzwimmer
HD video contains an animation by Michael Amstad

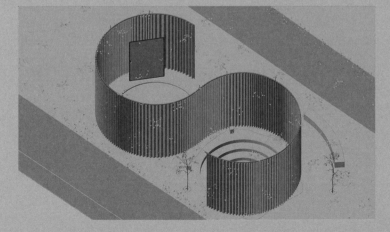

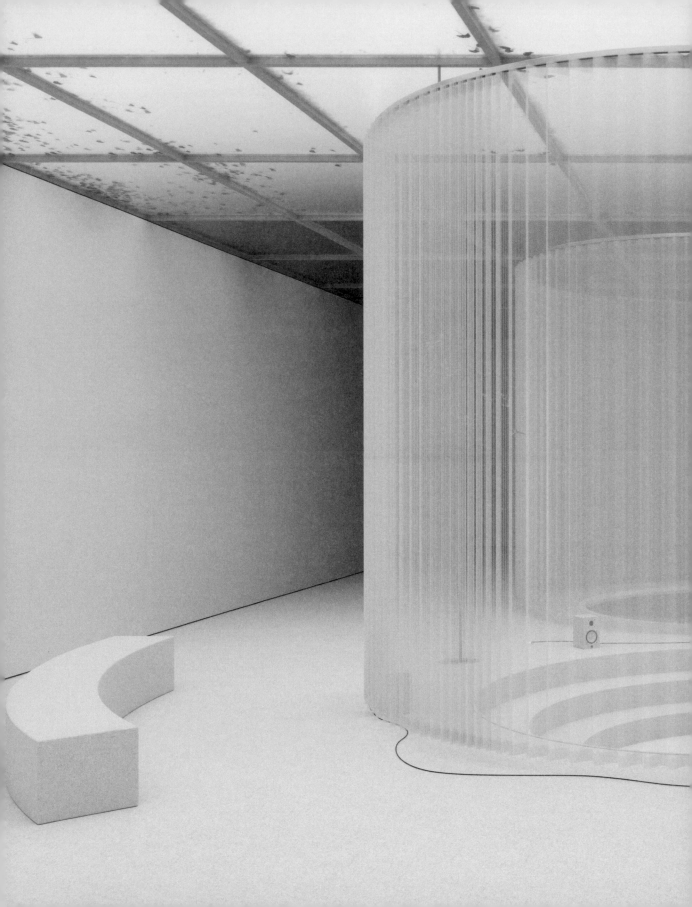

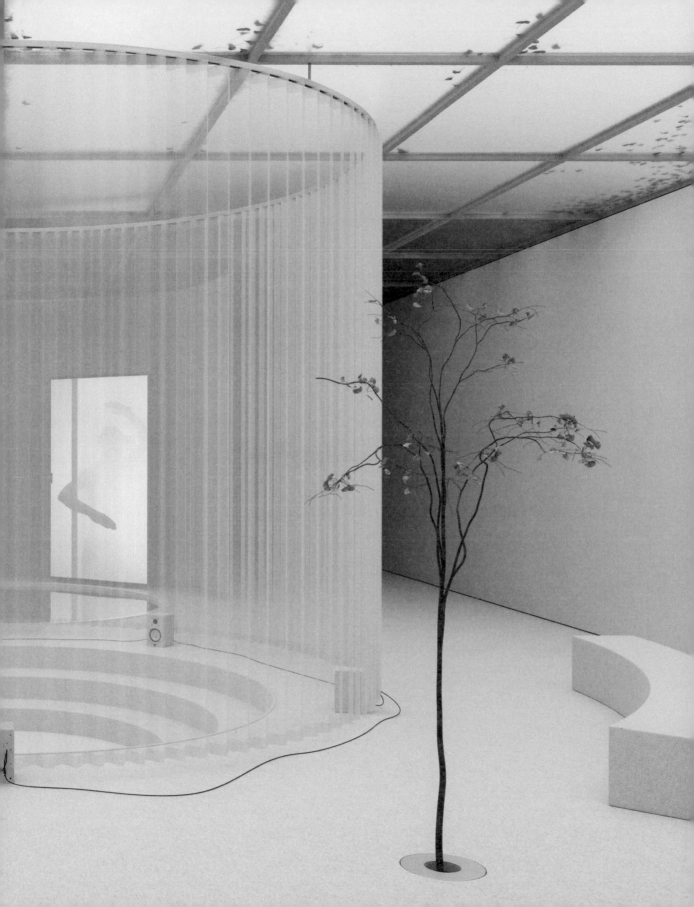

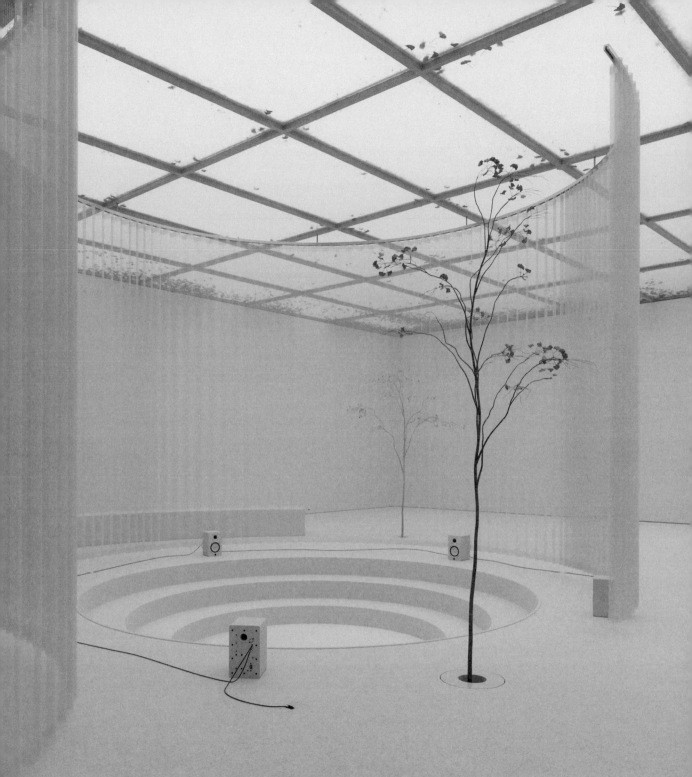

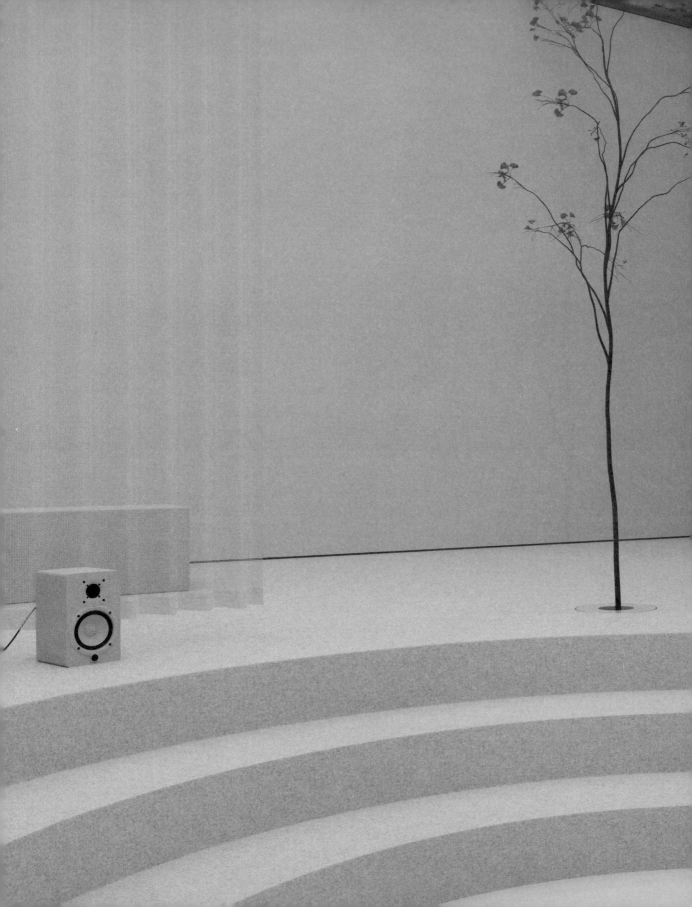

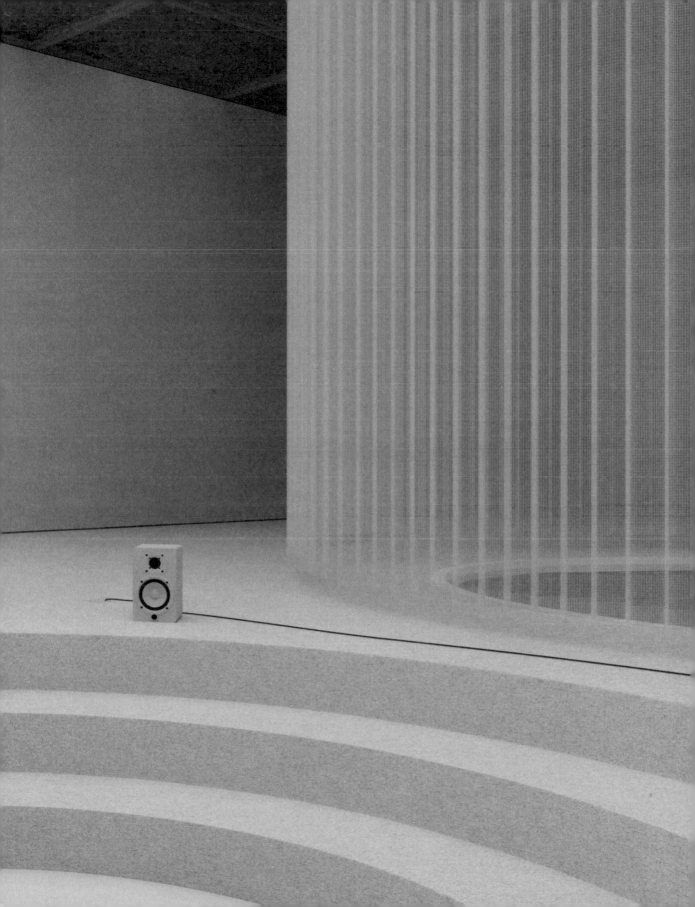

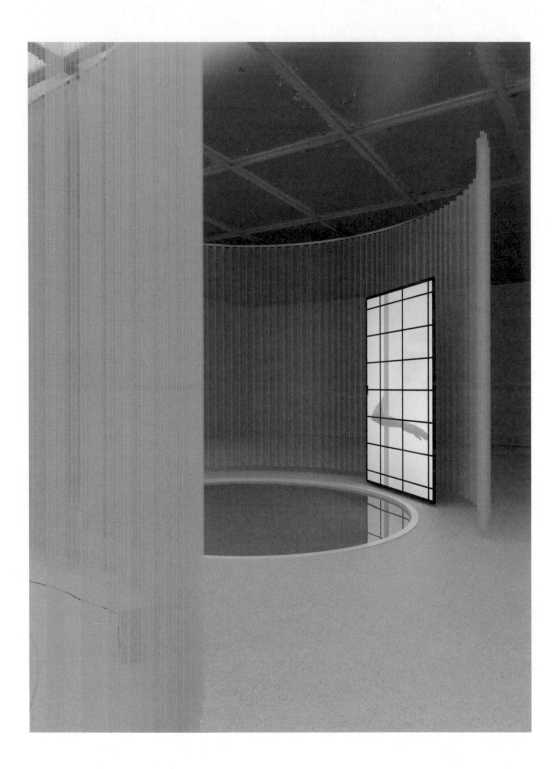

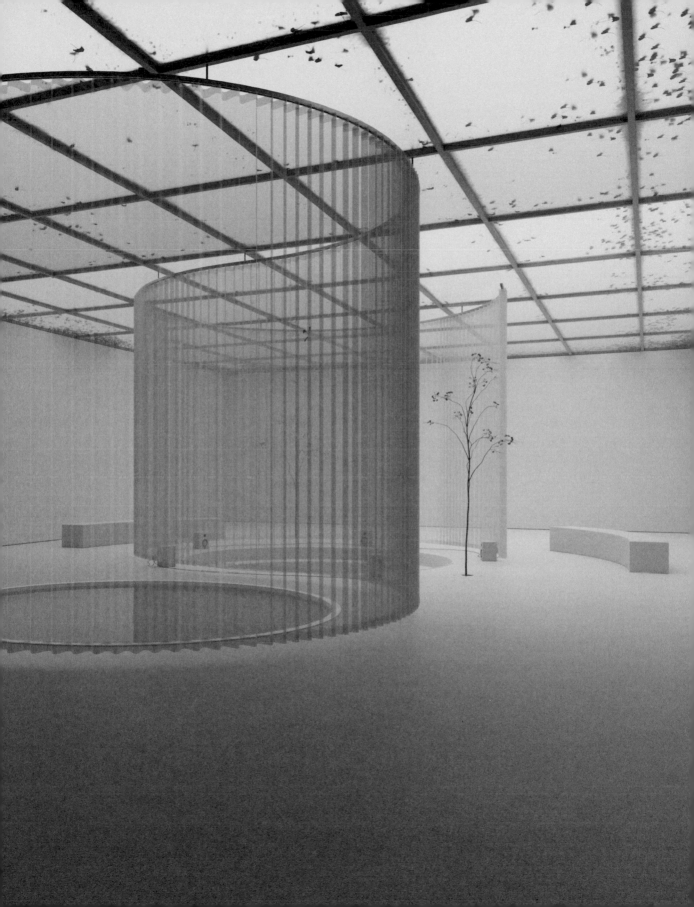

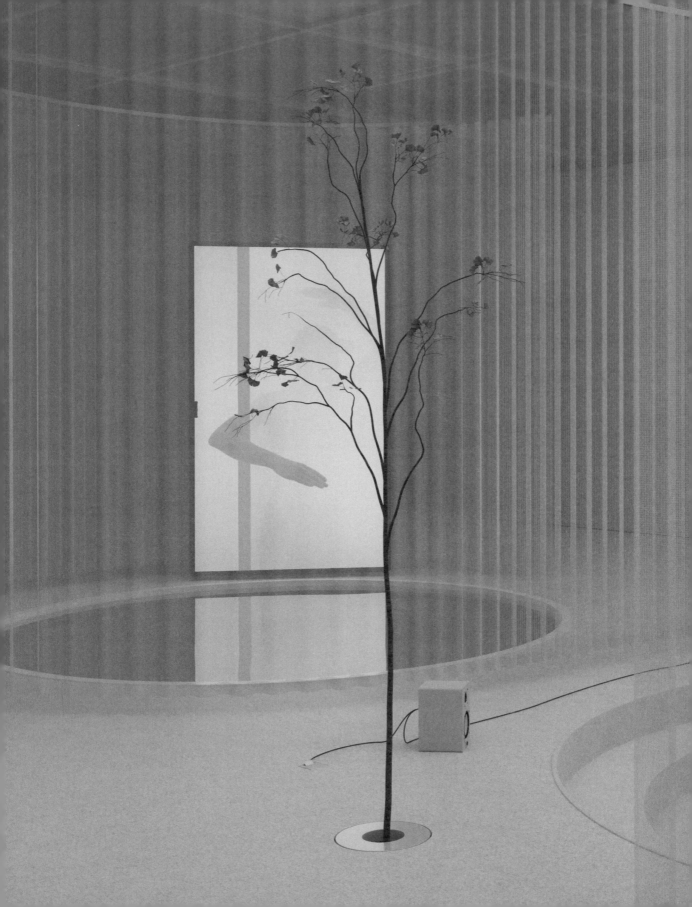

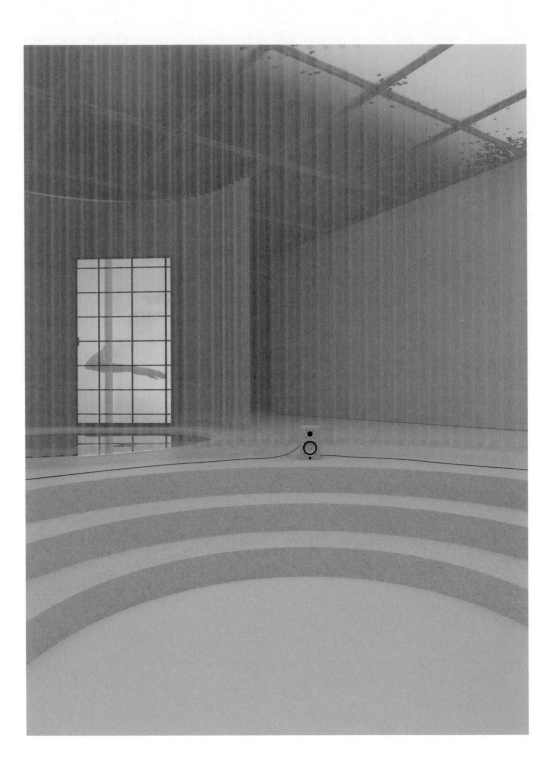

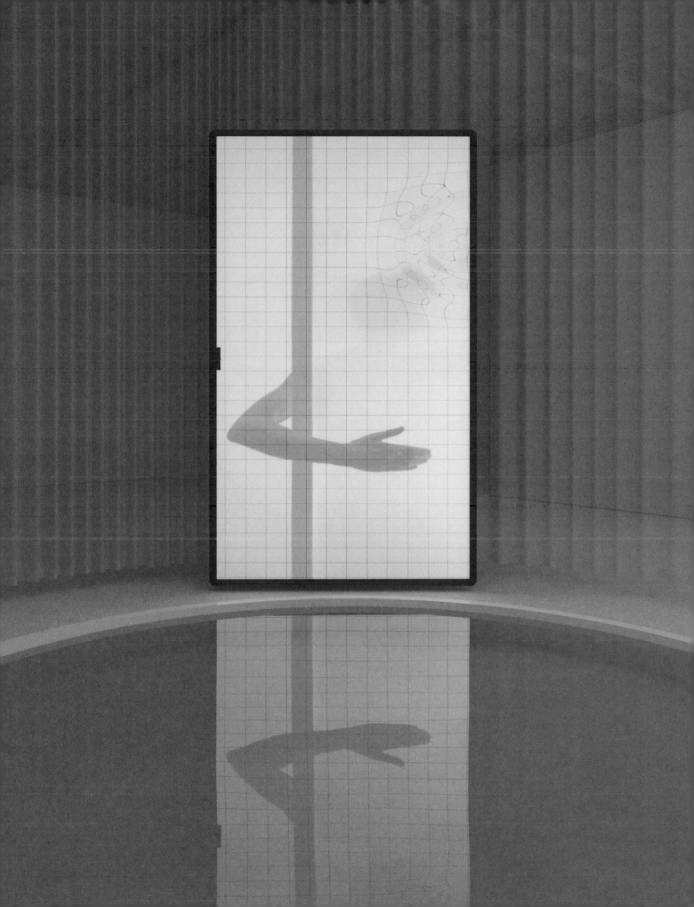

Swim sounds
Anna Barfuss

"[683] Is water sexy?"

"[684] Water is sexy."

"[687] Water is sexy. (The sensuality of it tantalizes me when I'm near it.)"

> Footnotes beneath a full-page photographic image of an opaque, rippling water surface, *Another Water. The River Thames, for Example* by Roni Horn

STROKES

One arm reaches out as far forward as possible, breaks the surface of the water – a gentle splash – with the palm slightly turned out and elbow almost fully extended; then, with your arm stretched out fully, you glide forward in a stream-lined position. Next, the palm turns slightly towards the middle axis to "catch" the water. The hand pulls back while the elbow bends, and one's full power can go into the pull as the arm extends out towards the back.

The hand, now relaxed, begins to extend forward again. As it passes the shoulders, the body rolls towards the other side. The head turns slightly sidewards, in the direction of the rotation, in order to breathe, with half of the face still beneath the surface of the water. As the hand enters the water, you should be fully into the breath. When the hand initiates the catch, the head turns back to its straight position for the underwater exhale.

In rhythmic movements, body rotations follow the controlled beat of the arm entering the water and the breathing sounds at every third stroke (or every fourth, among various possibilities), accompanied by the splashes of steadily alternating leg kicks. Voices and splashes, amplified in the world of echoes to which indoor pools give rise, intermingle with the various rhythms of different bodies swimming their laps. As signs imbued with corporeality, they each trace back to a

specific body. The sound of heavy breathing accompanies the beginner practising the front crawl. It indicates a proximity to other states of arousal, to bodily encounters. In the short film *The Other Marilyn*, gasping sounds accompany analogue film footage of a dimly lit, night-time water surface. A swimmer wearing a bathing cap stands out against the dark, flickering Black-and-white image, executing her strokes in unquiet waters. Director Brenda Longfellow re-enacted the record feat of the young swimmer Marilyn Bell, who crossed Lake Ontario in 1954 at the age of 17. Longfellow employed archival footage, sounds and music from the era, interwoven with filmic hallucinations of an athlete pushing herself to the limit. A female voice recalls idolising this young swimmer, who instantly became a national icon, while growing up. The voice parallels her with another idol from the same time, equally embedded in another patriotic narrative, who shared the same name.

"Everywhere where there is an interaction between a place, a time and an expenditure of energy, there is rhythm".[1] In *rhythmanalysis*, as it was understood by Henri Lefebvre, it is the body that becomes a metronome, a tool with which to sense its own rhythms and – starting from there – to perceive rhythms of various sources in its surroundings and in everyday life, no matter whether they take the form of music or of social events.

Rhythm in its present-day understanding implies measure and law, but in pre-Socratic philosophy, *rhythmós* was understood as the momentary arrangement or form of something ever-changing, of flows or atoms. The semiotic shift to today's meaning emerged with Plato: he succinctly describes rhythm as something generated by "slow" and "fast", placing it in close proximity to metric measure. It is here that, according to Émile Beneviste, the "vast unification" of the world, "under a consideration of 'times', intervals and identical returns"[2] sets in. But so do its questionable heirs, the cosmic models of idealistic and speculative philosophy that draw on it in order to subject the universe and human beings to a uniform, organic rhythmical pattern.

Measurements like the metrical foot, the *poús*, can be traced back to their bodily source: to the rhythm of walking.

The soundscape of public pools reflects movements organised in lanes within a confined space that can get crowded at times: there is a pulse, a competitiveness. One must constantly modulate one's pace, otherwise the distance to another body will inevitably decrease and perhaps result in unpleasant physical closeness or a disruptive touch. And if a swimmer happens to use training aids like fins or a pull buoy, the chances of this happening are high. The temporary limitation of one's choices imposed by moving between colourful lane lines allows the logic of

everyday duties to be suspended, narrowing it all down to a sequence of strokes and rotations: nothing else matters now. Muffled but strangely high-pitched and sharp noises underwater, and gurgling and sucking sounds from the overflow drain, add to the indoor reverberations of entangled voices and splashes. Sunlight draws a distorted grid pattern on an outdoor pool.

It's different when swimming in open water. One's confronted with a humbling vastness, home to more possibilities than one can redeem. As an open-water swimmer, one is immediately alone with the lake or ocean; there might be others watching casually from ashore, but they're farther away. Out there, swimming and bathing intertwine; one's attention to the conditions and temperature of the water are heightened. In a lake, one moves across a top layer of sun-warmed water while the body's lower regions are immersed in a cooler layer. Cold undercurrents can rise up and touch me. And immersed in turquoise or an earthy green, another world opens up below me. Buoyancy permits a different range of movements than on land. I bring my body into a streamlined position and, as I plunge my head underwater, I hear the buzz of a motorboat that might be multiple kilometres away. An undercurrent causes pebbles to crackle against each other. My limbs move through the water, and I spread my fingers to sense its texture. Its viscosity feels like an embrace. My whole body is immersed in it, a film enwraps my rhythmically moving limbs. As experiential as our accounts become when we talk about open water, the memory of it feeds into its allure, urges its repetition.

MIRRORINGS

This seductive quality, this mesmerising complexity enthral the water-obsessed artist Roni Horn. Clearly drawn camouflage patterns of grey-blue and black, effervescent grey-beige and rippling blue surfaces are among the various, ever-changing forms the River Thames takes in her photographic work, *Another Water. The River Thames, for Example*. Each manifestation varies in its colour and texture, at times opaque and ominous, indexed by footnotes in which a poetic, interpersonal dialogue unfolds. One finds oneself immediately drawn in:

"[600]What do you know about water? When you talk about water aren't you really talking about yourself? Isn't water like the weather that way?"

"[601]What do you know about water? Isn't that part of what water is, that you never really know what it is?"

Different personas of the river's surface emerge in swirls and markings, usually lost in the stream to the human eye, meandering between terrifying,

menacing, and poisonous qualities in the form of black water and water's alluring, inviting power. In between, literary references – to Emily Dickinson and Edgar Allan Poe, among others – broaden the conversation, but a darker, more morbid level is also added in the form of police reports on people who drowned themselves in the river.

The water surface as a mirror also appears in the story of Narcissus and Echo, where, after rejecting the reverberated courtship of Echo's empty, limited voice, Narcissus mistakes it for an interface to the desired body of an Other.

DRAFTS

Notions of the unfathomable have always surrounded narratives about oceans, rivers and lakes, encouraging analogies to the workings of memory and the mind. It was true of the topographical model of the psyche employed by the empirical psychologist Gustav Adolf Lindner, based on Leibniz's concept of an "ocean of darkened imaginings",[3] from which conscious thoughts protrude like islands. Later, depth and bottomlessness would delineate Freud's concretised notion of the unconscious, hinting at his interest in Romanticist ideas and speculative philosophy, with their preference for the deeper insights of the night. A competing model of the psyche, introduced by William James, describes it as a stream of consciousness, as a continuous flow of presences, of sensations, thoughts and emotions, in a succession between substantial and transitive states.

Attention thus emerges from a sequence of choices – that is to say, between preferring, welcoming, or rejecting certain aspects of its object: there are always certain parts of it that speak to us more. The object is surrounded by a fringe or halo that contains its mode of functioning. If we try to remember a forgotten name, we are faced with a very active gap, a kind of imprint that occasions its return to mind and announces itself with a sensation when we approach its reappearance. Sometimes there is only the rhythm of a forgotten verse left in its place, or the first vowel of a forgotten word, exerting a continuous pull. "Every definite image in the mind is steeped and dyed in the free water that flows around it."[4] It is at its fringe that its significance can be found, where continuously generated associations relocate it in the present.

Water fascinated the English Romantics, both as a motif of Greek mythology and dreams, but also because of its physicality and musicality. For Percy Bysshe Shelley and his peers, it embodied an ideal state that contrasted with the coercive nature of the society they lived in: one's immersion in it evoked a temporary preference for sensory perception over rationality. Swimming in the Thames was part

of their education during their time at Eton, alongside the study of ancient Greek and Roman texts, but it also bore within it the possibility of escaping the militaristic severity of their schooling. And both in and by the water, alternative drafts and counterculture-like concepts flourished in opposition to the coercion of their era. More than just being well-known for his eccentric habits, Shelley surrounded himself with radical pacifist, anarchist and atheistic ideas, advocated vegetarianism and so-called free love, and read Mary Wollstonecraft's book *A vindication of the rights of women*. Although he never actually learned to swim (and eventually died by drowning), his deep longing to be close to open water throughout his life permeates his writings. Looking down into the clear seawater from his boat, he could catch a glimpse of the plants and animals that populated the underwater world. Imaginings of what lay beneath the water's surface, and its mythological inhabitants, also fascinated a subsequent generation during the Victorian era, the Pre-Raphaelites. Half a century later, while at Cambridge, Rupert Brooke would swim naked with Virginia Woolf in Lord Byron's pool, a natural basin in the River Cam. For Brooke, swimming was a ritual that opened up a state of heightened emotionality, but he also experimented with other types of exercise reminiscent of *Life Reform* movement practices, aiming to get closer to a wild and "natural" state. Woolf observed that he had gathered a group of associates around him and established a cult of swimming, of "flower-crowned, laughing swimmers [...] clad in primitive clothes".[5]

Virginia Woolf referred to currents and a state of submersion when describing her own writing process. In Woolf's novel *The Waves*, atmospheric interludes set up a backdrop infused with light, water and waves for the characters' monologues,[6] soliloquies that negotiate their inner and outer states of being. By laying out their porous selves and their dependency on one another, the exploration of their interconnected identity formation can be seen as an alternative to Lacan's account of subjectivity.

[1] Henri Lefebvre, *Rhythmanalysis. Space, time and everyday life*, trans. Stuart Elden and Gerald Moore (London: Continuum, 2004), 15.

[2] Émile Benveniste, "La notion de 'rythme' dans son expression linguistique" in *Problèmes de linguistique générale I*, (Paris: Gallimard, 1966), quoted in Pascal Michon, "On the Concept of Rhythm Episteme", *Rhuthmos*, 2018: http://rhuthmos.eu/spip.php?article2299.

[3] Gustav Adolf Lindner, *Lehrbuch Der Empirischen Psychologie Als Inductiver Wissenschaft* (Vienna: Carl Gerold's Sohn, 1880), 56.

[4] William James, "The Stream of Consciousness" in *Psychology* (Cleveland & New York: World, 1892), Chapter XI.

[5] Charles Sprawson, *Haunts of the Black Masseur: The Swimmer as Hero* (London: Vintage Classics, 2018).

[6] Kate Flint, "Introduction and Notes" in *The Waves*, ed. Kate Flint (London: Penguin Classics, 2000).

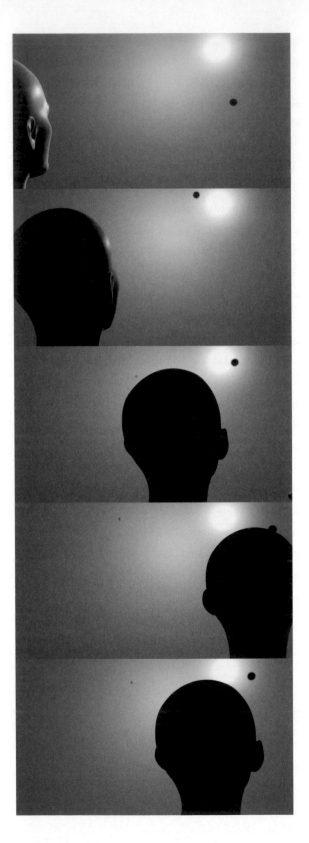

Stills from *Atmospheric Disturbances*, 2019
HD Projection for a live performance, 43 minutes
3D Animation by Michael Amstad

Closer to intuition

A conversation with composer Lori E. Allen

Lori E. Allen: First of all, *Manuel* [the 1985 comic/graphic novel by Rodrigo Muñoz Ballester]. Gorgeous!

Armin Lorenz Gerold: Mind-blowing.

LEA: At one point I got lost in the story, visually. I was following it and then halfway through I was completely lost – trying to think of why you shared it other than it's beautiful. And then suddenly hearing each cell in terms of how it works with the next, with silent punctuations between each stop-motion image. It began to score itself.

ALG: I did look for other work by the artist, but one of the few things I found out is that he was a sculptor, which you can see in these drawings. They have an intense physicality to them. All these different perspectives he adopts at once. You can imagine that the person who did them walked through all those steps first in their head, and many times on paper, before putting them down. It's so convincing because so much care has been put into bringing all those elements together.

LEA: Every line, every stroke, was really similar to an engraving or a chisel. Very labour-intensive. The melting of him as a narrator for example. In the dream state, his face slowly deteriorated

or became abstracted. Like you said before, the whole piece, even though it's in a flat medium, is three-dimensional. But also, the way time has been illustrated, in between the cells of the comic book; the progress of the illustration when shadows are growing, even the hair. Where did you find it?

ALG: My friend Daavid Mörtl sent it to me. I've been fascinated by the comic ever since, and I wish I could translate this fascination into my stories and storylines. But maybe a complex work like that can't just be accessed simply from one point of view, and only reveals itself by continuous observation of it, somehow.

But it also has a queer sensibility that takes you through queer trauma, I thought. I read the story as him, the narrator, falling in love with this guy Manuel, but the object of his desires seems to differ from the person he projects them onto. Manuel isn't just a straight guy who rejects him: he seems to embody a queer archetype that comes to live somewhere between the narrator's idealisation and loneliness. The rejection he faces breaks him, to some extent, and I can relate to that from a gay point of view. For a gay person, looking can be the first encounter with desire. And as you get in touch with your desire, you still have to negotiate this 'otherness' with the society and culture around you. Even when you come out, there is always a

dialectic process going on. I feel that the author finds a way of telling this specific story, but also contributes to a broader queer narrative, which is of course always subject to change.

LEA: The queer sensibility aspect I really feel in the melancholy. I think the difference between a queer romantic fantasy and a straight romantic fantasy is that in the queer fantasy the default is towards the melancholic; that it should fail or disintegrate, in other words.

It's okay that it does, it's almost as romantic as it being successful. But then if you look at straight romantic fantasy and the narrative around it, it tends to be more goal-oriented and in the end, you win; you get it; it is affirmed. Whereas in queer romantic fantasy, the affirmation is almost that it failed. These aren't new ideas, it's been documented and written about lots, but the fact that it kind of gets reproduced in a readership that identifies as queer again and again is the extraordinary thing about it.

ALG: That's exciting, because even the attempt to fail produces such an impact that throughout the book we see layers of the city, for example, gravitating around his pain. The disappointment in being rejected becomes the catalyst for an exploration of the world that surrounds him and its detail.

LEA: Well, the failure is richer. In that dissection of something you want, and when you get it in small pieces, your experience as a whole is like a sum of microscopic parts because the trajectory has already been dictated. Queer narrative often contains an appetite for sadness-as-triumph rather than assimilation or acceptance. I think

these little moments are what make the book so sonic, because it's fleeting: it's like an accumulated series of fleeting moments and that's what sound is. It's closer to intuition as well, because if there's nothing material, and all you really have are these events that happen and then they're gone, that is what characterises sound.

The way the story is told visually is almost how you would apply effects to sound. You can see delay in these images, you can see reverb. You can see re-sampling, time-stretching, decay and sustain.

ALG: There's this one abstraction of Manuel's portrait which is clearly a photocopy effect rendered into the drawing, which is basically like sampling in music.

I think it's good to bring up *Manuel* again. Like you say, it has a sonic perspective, but it is a story told through images, which I can relate to in my practice. There always seems to be a conflict in working between these opposites, for me. I have a similar interest in telling a story or making an image, but only with the tools of sound. Do you understand what I mean?

LEA: I don't think that between the eye or the ear one is superior to the other. Both of them are in constant negotiation about making a decision about what's real. This phenomenon is happening equally between eyes and ears. You can hear things that you can't see, and you can see things that you can't hear. That's the cauldron where all this theory about sound and vision can sit. It's because the relationship between the two is so murky and it's manipulable, it's a malleable relationship. It gives us the clue that there's something unfixed on both sides. Neither of them is a fact.

ALG: But then again you work with sound, so do you have to investigate that aspect more thoroughly?

LEA: You do, but I suppose in my practice I don't actually know whether I'm working with sound so much as what sound represents. For example, what a word represents on its own changes along the string of a sentence. And if there's a sentence, there's an idea. And if there's an idea, there's a belief, which is in turn a kind of sentence of images. So, a sound image and a visual image are interconnected; and in the space that is available to extract them from each other, it gets to a point where you can't excavate any further because they operate as one agent, even when they are paired with their opposites.

ALG: But maybe a more practical thought: most places that you actually show your art are places practically laid out for visual systems of communication. There's a big difference between one and the other.

LEA: Yes, but I'm talking about mind-pictures. Not something that you can show to someone else. That is so much in sound. I don't think it's as thick or as rich in visual imagery as in sonic imagery, because visual literacy makes images more likely to be read than to be received. Laughing and crying often sound the same until you see where the source of the sound is.

ALG: It makes the whole field of 'sound' so murky or even mystical, because it just doesn't start and end with the sound as a signal; it has many different layers to it.

Writing, for example, is part of everything I do – but it feels like it is the most invisible agent in my work. Before I would start to make a sound piece, an audio play and I would have the texts ready and thoughts structured and laid out, and then begin to build sound on it. The product might look like sound, but mostly it's just a story disguised as sound.

LEA: But I think that's what sound broadly is. Stories. Not so much told in words but in the timing of moods as they come and go. Sonic events are a report of what happened – is happening. I think the trouble comes when the sound is pushed back into a word in order to understand it. A crash or bang may sound angry, but then again it could also sound tired: so that object that fell from somewhere and made all that racket was because the shelf was too tired to hold it up anymore. Or, you could say it sounds entitled, as if it *demanded* to be on the floor and not where it was placed. I guess this creates an anxiety around making a decision to manufacture sonic ambience around words, or to allow the ambience to breathe out the words that are already there.

ALG: So it's not following the logic of pre-existing thoughts or ideas?

LEA: Yes, when you have a project and you think, this is going to sound this way, or you think of a project that you're going to do and maybe a riff comes to you or a beat, a rhythm, you think … Why? Where has that come from? Is it interoceptive, has it come off my own heartbeat, has it come off my own thoughts? Have I seen something else that has done this?

ALG: Yes, *Scaffold Eyes* for example. My initial idea was to show how it feels to just go out there and get lost. Something that is as equally intuitive as it is a reflection of that intuition through its editing. To go somewhere and try to immerse yourself in your surroundings and what you see and then translate that feeling back.

LEA: Like a commitment to not edit?

ALG: Kind of. At least in its initial transcription of ideas in writing. But that's what I mean: you have to open yourself up to something new, a new sound – and then later edit with a commitment to what made that experience interesting in the first place. I think experience is one of the most silent processes.

When composing the music for *Scaffold Eyes*, I chose to pick from different intensities I found interesting, rather than a particular style or genre, perhaps also to not get lost in melodies or in any over-arrangements, I think. I tend to do this quite fast.

There's this scene where the protagonist in the play is on the train and they start to see the humidity in the air settling on the train window, with the landscape passing by. There was this switch in the narrative from experiencing something external to an internal mode.

LEA: It was suddenly very interior; it was almost claustrophobic.

ALG: You find such sound transitions in ambient music a lot. Where there's no rhythm, but a surface represented through a synth. It narrows down sonically and the less space there is in reverb or other spatial effects, the more it intensifies. Something like that can be used to signal a sonic shift that underlies the experience being described in the text, or the voice doing the describing.

LEA: And it also goes to the limits of being perceptible to imperceptible, to the point when it becomes interoceptive. That's where you lose your distance to it. You mistake a thudding bass for your blood pressure or a screech for nerve pain. Then once it's inside, it becomes abstract again – or unnoticed, even.

ALG: Unnoticed is the best. Or when something breaks through. There is a scene, where we listen in on the protagonist's thoughts, which is intercut with an exterior phenomenon. They encounter a scaffold and dotted red lights emerging from a crane in the dark night sky. I used a drone sound to represent the distance and bells to represent the lights. I suggest correlations between high and low frequencies. There is such a spontaneous but rich dialogue between image and sound that I sometimes forget which came first as an idea. Did I actually 'see' the image before? Or did the idea that it would resonate come because I had a sound in mind that made me recognise it as an image?

That's how I operate when I design sound: I look for things that have a similar quality and try to see if these things resonate the way I want them to. I record those segments mostly in one take. I try not to clean it up too much afterwards because I always fear you can hear the mind working, almost, and I don't want this 'human' part of the recording (audible in missing a beat, for example) to disappear through the edit. It's actually quite intuitive and fun.

Music becomes like a library; you look for different intensities in all the productions that

ay evening in late August. She wanders
s streets linked to a canal that divides
wo halves. Her thoughts are diffuse and
pted by looking at her phone relentlessly.'

3. 'It is early September. I enter Kreuzberg 61's town hall
through the main entrance passing by a porters' lodge
A man is barely visible behind glass. Gently lit from the
side by a small table lamp, half his shape disappears…'

4. 'It is an afternoon in July as I return to Innsbrucker Platz.
The heat is standing in the air. Every now and then a breeze
cools the sweat on my back between my shirt, another
layer of wet skin, and my rucksack; it makes me shiver.'

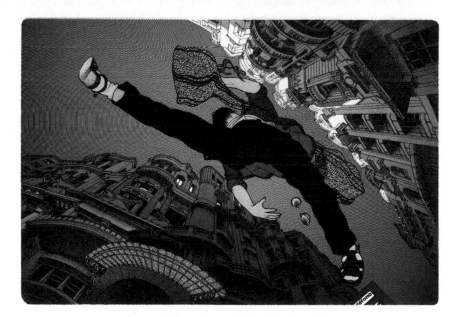

Scaffold Eyes, limited edition CD, The Wormhole, London, 2018 (Photo: Dan Ipp)
An image from *Manuel*, De Rodrigo (Rodrigo Muñoz Ballester), La Luna de Madrid / Ediciones Libertarias, 1985

you've more or less internalised over the years without archiving them.

A lot of what I do is shaped by imagining a 'listener'. It's an act of communication, because I'm always imagining how a sound transmits to someone else's ear and building something that they could connect to – which of course goes hand in hand with a lot of my plays featuring quite didactic first-person journeys through specific geographies or routes.

I would even describe this as building 'invitations', because this interaction is shaped by interrogating people's responses or reactions at live performances, for example. There is always a dialogue. This year has been strange, as this interaction has changed its mode a lot, through the isolation and the technology that has thrived in this exceptional global situation. In response to that, I wonder more and more if this process could become something that exists just for myself and is less concerned with reciprocity, if that makes sense?

LEA: I wonder if it's really about this year – well, I'm sure it's also something about me finally stopping this wrestling with myself and just minding my own business (*both laugh*). And doing things that I just like doing privately with select people. Being local, I suppose, is really a good reminder that that is really all you need. If you're doing something for you, people find their way to you. It's a kind of silent siren call.

ALG: Speaking of life-changing years, or phases, this too indicates how you can grow out of, or through, sonic experiences. As a teenager, I consumed anything. It was only later that music

would also frame something social and cultural around me in a tangible way. But I try to come back to that moment a lot. I never questioned it as a concept. When I started to make music myself, I also always tried to appeal to 'listeners' with this idea of impartiality. But again, this year has made me reflect on that and perhaps I've become harder in a way. Do you think there is a way of learning to expose yourself to new sonic habits?

LEA: I guess that depends on what you're listening out for. If you're listening out to create more invitations or opportunities, when you put your ear there, then that's what you're going to hear and that might be limited. If you're not listening out for anything, you may hear more.

ALG: The piece I'm working on for my stipend is influenced by this interrogation with the outside I was talking about. It takes into account, in relation to the isolation of 2020, that the means of communication have shifted. Like you say, it depends on what you are listening out for. What if that 'listener' I engage with has changed?

LEA: Like that listenership is being audited?

ALG: Maybe. At least that's my assumption.

LEA: Does it have to be clear to you what your methodology is? If it has been up until now, maybe the point is that it is "decomposing", in a way, and you learn how to not have a methodology. That would be the opposite for me. I would actually benefit from being more practical and less random. But I think there's a hunger around it that is trying to validate what you're doing against this greater

context, which has so many details that the whole thing is too pixelated to try to work out where you're fitting into it? I wonder how valuable it is to constantly reassess how you're working, what you're working on rather than actually just carrying on doing it, and let it show you what you're doing. Makes me think of speaker drivers tirelessly pushing and pulling air into a pulse you can recognise.

ALG: But there is a specific interest in my work about how the sound translates. Maybe it's not so much the sound, but the way a story is told through narration. It's as if I need to understand how those syntaxes register with a listener. I've never really questioned that part of it.

Overall, the Covid crisis has revealed more differences between people than actually bringing them closer together. I remember there were people whom I automatically assumed had a similar mindset, perhaps because I never questioned it. Then they voiced something which made it almost impossible to move on without accepting that thing which stood between me and them. I became interested in the idea that this could also change the relationship between the musician or artist and the 'listener'. That's also what I want to do with this piece, and see if this ambiguity can be translated.

LEA: Thinking about the listener, again, when you make a piece of work, the beauty of it is that you get to experience practising letting go of something that means a lot to you. It's actually quite scary, and full of potential, that when you do put a piece of work out there it doesn't matter what you meant it to be anymore.

ALG: Yes.

LEA: But as a way to pre-empt that conversation or go in with it, thinking about a listener before you even made it, I'm interested to hear more what that means to you. And how you think that's achievable.

ALG: What do you mean?

LEA: It's so hard to design how someone is going to feel about something.

ALG: But the way you lay out a story, you have to narrow the complexity to have people hear it.

LEA: Yes, but that doesn't mean that people will see what you sculpted. I mean, *Scaffold Eyes* is a perfect example. Even in the title, it's scaffolding. You created a structure that bridges, but it will never be the image that you've created. An audience is a kind of A.I., a collective digestive process, and if you could render it back to you, you might have some recognition of what you meant, but it would be utterly fucked up, because it's gone through everybody's digestive system. But that's a good thing.

ALG: But I have to work on the assumption – I don't mean to predict how they feel about it – but the assumption is the idea of how I want to be in touch with people. That it could exist in a transactional space between us. That's the exciting part. But I feel it has always been as exciting to *not* know what that process is, and the more you learn about it, the less energised or tension-filled it becomes.

Gerold performing as wirefoxterrier.
A night with Armin Lorenz Gerold & Eli Levén at
Konsthall C, Stockholm, Sweden, 21 February 2020

Performance presented as part of
The physical world was still there, curated by mint

(Photos: Paulina Darlak)

LEA: Maybe because the anticipation is gone. Have you ever read *The Master and Margarita*? There's this one scene that really stuck with me. One of the characters has this globe, and they're in this bird's eye view of the world. The globe is an organic, living object, in the sense that it pulses. The two characters are viewing it from afar, considering it and talking about it at the same time. The whole globe has all of these fairly discernible red lights and they're all over it like the measles. The closer the characters look at it, the more they realise that these lights are like broadcasts of people. They represent the pulses of people and whatever they are putting out there. This image has stuck with me, especially when working with sound. Everything is shrouded in this fog, but then there are these tiny blinking lights, each of which has a rhythm to it. Each one is different, but if you look really closely you can see how intricate things are and how the whole thing is a web of all these different lights, each blinking through the fog, at their own speed.

I find that I return to that image a lot – when I'm thinking about what I just did, and what I've agonised over – because it explains something to me about the difference between relevance and existence. Did anybody hear it? It's kind of morse code: it's a "tap tap tap", putting stuff out there. I like to think about this idea, coming back to what we talked about before. What are you listening out for? You have this tiny ear trumpet and you can zero in on these morse codes; and you might know how to interpret morse code, but that might not be the language being put out there.

ALG: I value those moments of 'crystallisation' or 'realisation'. Or right before you build a conscious knowledge of something. Like a sensation of not knowing something yet, which you're listening in on.

LEA: The moment of discovery before you catalogue it.

ALG: Absolutely. That's in sound too. The way you are exposed to something and it takes a moment to adjust or get in tune with that world. That has always been an important tool, in terms of pointing out something that people already know. I've sent you texts by W.G. Sebald. There are all these long and winding, almost romantic descriptions of places discovered through walking, but then he excavates the history of these places and allows you to see the atrocities of the 20th century in them, for example. It informs the same place, even if just on the surface.

LEA: The link you sent me about Sebald did describe the experience of the eternal excavation of life. That we are so built up in our thoughts and rhetoric – and in the business of understanding – that we're having to scrape it off ourselves at the same time. Even in the action of being still, you collect all of this stuff that you have to remove in order to move forward again.

ALG: Sometimes I think that, especially when you work with narration, there is this sense that – even to yourself as an author – you have to convince yourself that you can point out two very different things, but then connect them to each other through a story, speech or a sound. Or when you leave an ambiguity, whether people will reach a conclusion that you intended. That is of course important, but there is also this hope that you were

wrong about that assumption in the first place, and that – by accident – you've created something new or different. Something that isn't intentional, because you and the listener are both piecing it together.

LEA: But that's also what's so great about it. It gives us a lot of work to re-excavate with each other. Check with each other whether we understood. That is such a nice process, when you have the sensation that you're actually really talking and really hearing.

A few weeks later.

ALG: I'm feeling more relieved now. Reading back over what we talked about was nice, and I found a few more points to discuss.

Releasing my new single *Call me Babes* in between was important; I couldn't really see how much of a hold it had on me. I'd like to just shake it off, but I am so aware of how much work really went into it. I didn't really see its potential at first and I was so worried because Robin Plus and Enver Hadzijaj were involved. If it was only 'my music' it would be different. But making it a collaboration, I had a responsibility to push it in terms of promotion. And all of that social media involved. I was overwhelmed by how many people shared the video and, on the Monday following the release, I was just exhausted. I got a really nice message from a French art professor and we chatted a bit. He was talking about 2020 and his resolutions and mentioned he would like to be more

daring and poetic. I think he read my response as a bit cynical, just because at first glance I found 'poetic' such a cute buzzword. But he insisted on the idea that there is no progression without poetry. And that you have to use it as a tool. He pointed out that through my reading series, I became a bit of a poetic vector for him. I love that word. I'm not saying that because it was flattering, but because I really couldn't hear myself and what I was putting out there anymore.

Looking at charts and numbers all the time, I tend to forget to focus on the more powerful aspects of poetry or music, to trust myself.

I felt that at the beginning of the pandemic there was this heightened sense of listening, as if people needed to recalibrate the way they took in and emitted information. As it progressed, it became much more muddy and harder to stay optimistic, as it also became clearer that it would go on for a while and reveal much greater complexity.

LEA: I understand what you mean about not being engaged with it in the way of an audience, in terms of having the space to be an audience yourself. When you get those brief opportunities, about what it is to experience your work from comments like this, that's what you're going for in the first place. You forget that when you put it out there, you're concentrating on doing. Showing successful numbers is not an accurate reflection of people engaging with it in the way you had to engage with it in order to produce it. Which is lost when you're putting it out there.

It reminds me of this other piece by Robert Ashley that you sent me, coming back to our conversation about 'invitations'. You were just making me think that doing work, disembodying

yourself through your work, poetry, prose or musical poetry, is a reversed invitation to see yourself inside out. Robert Ashley links into this in the very first moments of *The Backyard*, where one line meets another. The boundary of the known meets the boundary the unknown is drawn by. The idea that you're maybe not extending an invitation to yourself, but to be the embodiment of something or someone else. Which is a tough thing to do. Or just seeing through someone's eyes. I suppose that when you're writing fiction, you're doing that all the time.

ALG: But there's an element of confrontation in the performance of such work, that I didn't think about last year, which is so fundamental to what we do. And it's strange that 'the audience' or the idea of a 'listener' is shifting more and more into this digital space.

Parts of my memories of performing in actual spaces include a lot of ambivalent and confusing details, if that makes sense. These memories include people engaging with work. There would always be this one person in an audience that would come up to me to let me know about a specific way they were creating a connection to the piece. But there would also be the people that would constantly look at their phones, probably arguing with their partner, or someone who just couldn't listen because they had no headspace. All of that, the multitude of shared experiences in such an event, broadens your horizon as an artist and you learn how to deal with it. I like that in actual spaces there's a higher chance of being exposed to people outside of the bubble you've created online, and part of the process for me as a performer is to learn about how these people understand and

experience things as well. I miss that, because this practice has always helped me look forward. It takes away the pressure of what you think something should be, because it's more layered to look at it through the lens of many different people at the same time.

LEA: You have to commit to that from the very beginning: you make a piece of work and you can't control how it's interpreted. That is the real power of it, that you let go and it becomes something else you didn't intend. Often, through this lens, you are also able to see what you did accidentally. Or at least another perspective. It's very intimidating to do that in front of a crowd of people. That's my favourite place to do music. In the digital space, you don't really have your eye on the people who are receiving it. You put it in an envelope and send it through the post, as it were, and then it's theirs and more of an object rather than a witnessing. I was just thinking about the few times I've performed when my adrenaline has been so high that I hardly even notice what people are doing; I'm just trying to get through it. I haven't yet really experienced the sensation of enjoying my own work because what I'm mostly enjoying is that I'm surviving it.

ALG: (*laughs*) I absolutely feel the same. Your own perception of such moments of anxiety and nervousness are prismatic, almost. And while you are immersed, you can also catch a glimpse of something that is very random. I spot one person for example and they become part of my story. I remember when I played in Berlin for the first time, at a party mostly for artists at Südblock. It was at Christmas, lots of Christmas parties and they all

ended up there. Everyone was on coke. There was this lady, she was talking constantly, really loudly. She was sitting right by the stage. In retrospect, the whole show was about performing against her, for me. I think you just learn how to deal with something like that. But it's absurd; I remember her more than actually performing my music. In that sense, some of these unexpected elements of performance become you, too.

LEA: Funny, because she was probably not even aware of this race for the stage.

ALG: I remember a performance in Spain in 2019. It was a bit hardcore because it wasn't announced that the spoken word piece was in English, or maybe people just overlooked it. Every time I do something in spoken word, I realise that if you can't fully connect to it because of a language barrier, it can become really odd to follow for an hour, for someone in the audience. There were some older people there who, I assume, weren't fluent in English. At first, I was really happy because it was sold out, but then the energy dropped because there was this moment where lots of people realised that they wouldn't understand most parts. The performance was on Good Friday. After the performance, we stepped out of the museum auditorium and there was this huge procession going on. People dressed in catholic dresses, incense, carrying figurines of saints. And those weird crusaders' hats that the Ku Klux Klan adopted. It was such a weird moment for me to step out of this performance space into this other performance rooted in the city's tradition and culture. It created such a clash in my head. You think about the world you were trying to create within the frame of the art space, and then you see something like that and the bubble just bursts.

LEA: It's how vibrations work too. You have little pockets of something that's vibrating at this frequency, and then inside that there's another pocket that's vibrating at a different frequency. Especially in a city. You're at this museum, you've done an experimental performance, it feels really all-consuming – and then you go out and you're like 'what?'. Not the same wavelength at all, I suppose.

ALG: I love it though. It pushes me to think about it even harder. But both events somehow shared a ceremonial, or maybe even a mental aspect, with what was going on outside.

LEA: Quite a finale.

ALG: And I love incense.
So, I listened to your piece *Disintegration*. I wanted to talk to you about it because we've been talking about invitations, and I also see the piece you made as an entrance through language, and through voice. The voice of the narrator guides you through a landscape. I believe it came about from a trip across Ethiopia?

LEA: Yes, a collaboration with Rachel Pimm.

ALG: Retrospectively, I'm not even sure it needed the voice to guide me. It gave me some information, but I thought the sound already gave away a lot about the place it was talking about. Through the sound, it seemed so clear that it was about stone and tectonics.

Broadcast from home, online reading series during the first lockdown in Germany, 24 March–24 April 2020

The piece actually manages to make you feel you are going through stone, or even millions of different sounding stones. Their different textures felt very specific. I found it very clever that it begins with synth music: it gives you a little suspense, a sense of waiting, almost, before you are perpetually moved into the abstract field recordings. Are they field recordings?

LEA: I took bits of field recordings, made midi instruments out of them and pitched them to an Ethiopian scale to then combine with actual Ethiopian instruments. The idea of *Disintegration* was initially about the location that we went to, where the earth is trying to pull itself apart as it tries to form a new ocean. But it's also an area of the earth that has this intense mineral composition. We were thinking of how to portray this, and the responsibility that comes with being a visitor to this place – a place we theoretically have access to, and the simultaneous privilege and absurdity of 'access'. We tried to be very careful about being in Ethiopia. To be respectful of the land that was described by western geologists and scientists as the most inhospitable place on earth. Being shown around by people from there who live off the land, as harsh as it is made out to be, we wanted to make sure that any voicing was actually the field recordings themselves. Manipulation into something like music or an art piece felt similar to extraction, taking something that did not belong to us. In this sense, we tried to let the place speak for itself as far as that allowed us to communicate what we experienced.

So, the only way I thought I could do that was to use just the field recordings to build instruments, and the Ethiopian scale structure to pitch them. In the end I did also use actual Ethiopian in-

struments too. It was an easier task for me in many ways than Rachel, because I had field recordings that were, by their very nature, more separate from myself and my own perception.

ALG: Which is something that might not translate to the listener, unless they're given the information.

LEA: That's an interesting thing to bring up: there is all this effort behind the scenes that goes into something which would almost entirely go over your head as a listener. Not because it's complicated, but because you're in more of a receiving position. Whereas when we made it, I worried about my position as a 'taker' or 'extractor'. I had taken all of this personality from this place and I was tasked to relay the experience of it. I'm not sure if it's a good thing or not that all of this backstory doesn't come through. How do you judge it, on that basis?

ALG: Well, the work doesn't really stop at that point, I would say. As an artist you are able to provide more than 'just' a performance – you can engage through writing, for example. I probably wouldn't have guessed the notation, but nonetheless, it created a very specific place in my head. I think that's something incredibly important that sound can do. Not only depicting the space you engage with but opening up people's minds to pass through it. You have to make up your mind about it first, in other words.

LEA: You mean you create a space where you can be a visitor? You create a space that can house your experience *before* you have it? I agree.

Your associative powers undo censorship, digital drawing, 2019

Lori E. Allen with *Tears|Ov* at *Wolfgang Tillmans: South Tank*, Tate Modern, London, UK, 8 March 2017 (Photo: Philip Marshall)

And then you learn that you didn't know all that much about how much richer it is, compared to what you anticipated.

ALG: I think sounds don't give you a system of navigation *per se*. You're confronted with the complexity of a 'space'. And listeners have to learn to navigate themselves through that. I don't know what role the vocals play there. For me they were a good element of focus throughout, nonetheless. A focal point. So, you're navigating stone soundscapes and at some point, you come upon this real radio playing, scanning for stations. Which made me open up and think, 'I love radio so much'. There's something so specific about the sound of a radio scanning through frequencies. It's funny, most of us haven't experienced that in quite a while. The actual tuning: it's something that is very universal. I really felt that moment of being in the car and there was a nice space between me and that radio. It wasn't foregrounded. It's also a metaphor for being somewhere else, foreign perhaps. You switch through frequencies and you learn to decipher the codes that are being broadcast.

LEA: It was very enjoyable to do that section. The radio comes up almost inaudibly at first, but then it becomes very present. The way I managed to record that resembles my experience in the car. All of the vibrations you can hear before the radio becomes clear is me trying to record what it felt like in the car going over this terrain. So, it's actually a recording of the shocks in the jeep; it felt like we were driving on the moon, it was so forceful. Like it is when you're in a club, dancing: you feel it in your chest. Being tossed around like that – and having this vague awareness of other people

through the radio – felt so grounding. I really wanted to try to recreate that. The zero-d focus of trying to record the tyres on the terrain from inside the car, and suddenly feeling grounded in the world by the radio settling into my consciousness. It didn't matter *where* in the world, just in the world, broadly. I decided I wanted to get that across through that section of the piece. Because I don't think we ever named the place either. Rachel Pimm certainly referenced the "un-naming of things", specifically. "How do you name a place? What colour is this?" Are all my references even relevant here? That was the overarching shape of the work we sought to convey: the disintegration of language, space, earth, borders, geology, everything – subjects Pimm has been addressing in their practice for a long while.

ALG: I think that wouldn't have worked if you had given too many textual specifics somehow. I think that's almost a trope in composing audio pieces for me: leaving out the specifics of a place in order to maintain a complexity that suggests navigation, in spite of not knowing where exactly you are.

 You said it before: sound is closer to intuition; it plays closer to your senses.

LEA: It just cracks the imagination wide open. In terms of an image being connected to it. So, it's extremely manipulative in a way – even though I just pretended I was trying not to manipulate at all.

ALG: I had a sort-of job offer yesterday, about an audio play. I talked with a writer about composing something for a text of hers. She and the

producer, who was present too, instantly came up with the idea of a field recording, which I have a complicated relationship with. I started out recording them a lot, and even used them, but I always found microphones were not the best tool to record a place's atmosphere. There are very recognizable, universal sounds, of course, but a lot of other things get swallowed up if you don't isolate them from each other. It becomes a battle to control this environment if you have a specific idea. I'm trying to remove my practice from those tools entirely and find sound and musical metaphors that might give you a clue, but not those 'a-ha!' moments: that's the car, that's the train. Even though it feels really rewarding, I guess, if a text asks a question and then you hear proof of what you'd already thought through a sound. I try to hold that back and see how far I can go with it.

Over the last few years, panning has become more and more of a thing for me. In 2019, I started working with 5 Channel, and explored the possibility of moving sounds around, which allows you to portray an idea not only through sound but also through its spatial movement. So, if we're talking about a train, for example, you don't have to have that exact noise rushing by, you can also create something that imitates the process and creates a similarity, even though you still have the same sensation.

LEA: It feels a bit like a low-hanging fruit to just illustrate what is being narrated through audio.

ALG: I think it's really more about how much you can control that environment. I just never found I could do that well enough. There's this moment when you walk out with a camera and there's something you would like to photograph but you can't make the camera look at that specific thing because it's far too entangled with its surroundings. And there are other people who might do it by chance and it works really well. It depends on how you engage with microphones, I think.

LEA: I have my own doubts about my methods and ability with field recordings. There's certainly a lot of junk. And I notice that when one thing works, I might record another whole feature in the same way, and you can hear that in it. Of all the hours and hours I collected (for the *Disintegration* piece), I didn't actually use that much.

ALG: I guess so. I find it very painful to go through all those granular sounds again and find something.

LEA: I think that this somehow becomes very confused with the idea of what composition is when you embark on using field recordings. There is a lot of work out there that employs them. It's a bit 'come as you are', as well as this romantic idea that a field recording is its own natural synthesis of life. What happens when you want to turn it into a piece of work is that you don't actually have the tools to faithfully reproduce that – and it gets manipulated. You get snapshots. But I think there's also a tendency to use field recordings as this safe bet, as if you're delivering a contextual piece. But those recordings are edited to fit a certain length, or amplified in areas of the stereo field. Is it worth doing this, just sitting and listening to a place while you're in it? I don't know.

Atmospheric Disturbances
LambdaLambdaLambda, Prishtina,
Kosovo, 17 November–22 December
2018

Stereo sound installation, approx. 45
minutes

Transparent silk curtains
Exhibition poster, inkjet prints (81,4 x
59,4 cm), wind map, inkjet print (59,4 x
200 cm), lyric leaflet, 29,7 x 21cm, lillies

(Photo: LambdaLambdaLambda)

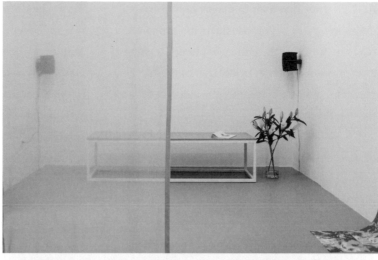

Scaffold Eyes
KW - Institute for contemporary Arts, Berlin,
Germany, 2 November 2017

Audiovisual live performance,
5.0. Sound installation, 45 minutes

Voice, five speakers on tripods
Semi-transparent silk curtains
HD Projection, 45 minutes

Performed by Doireann O' Malley and
Armin Lorenz Gerold with additional
recorded voice-overs by Miriam Stoney)

(Photos: Frank Sperling/KW Berlin)

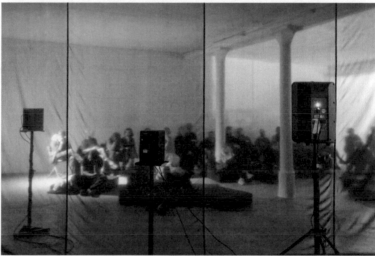

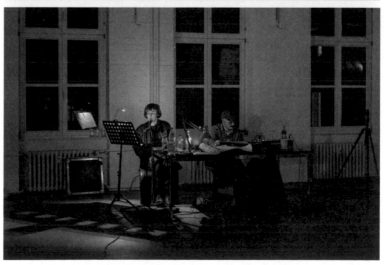

ALG: I see that a lot in magazines. You see dudes in nature with those fluffy microphones. It reads to me as '19th-century explorer'. It employs a certain romanticism or idealism of the fact that you can kind of maintain that synthesis you were talking about.

LEA: It's quite colonial, too. Because you're recording something natural about a space, whether it's for posterity, science, curiosity or your work, and there is this assumed attitude that you are preserving the natural reality of a space. You are taking something from it by observing it and being quiet: all of the stuff that goes into it, but then your little device is capturing it. It can't possibly contain the other necessary, present physical information it had. I mean, our ears are analogue, aren't they? What about how physiological comfort or discomfort contributes to what you hear? Sweat dripping into your ear; the muffled sensation of intense heat; the clarity and stillness of the cold. Maybe I'm just being a cynic.

ALG: I have two moments I want to share. I sometimes smoke at my bathroom window, and recently I heard someone hitting something like a glass bottle against a material I couldn't define. It was the most perfectly tuned sound I'd heard in a long while. Quite funny and sad at the same time. It's very Berlin: another person just lost it. But it was also the distance to it that was sensational. Everyone knows that moment, you go through a backyard and someone is playing a piano or something. I spied on someone playing a synth once in the studios around Berghain. It sounded so muddy and murky in the distance, and these other elements of sound floated in, through the ambience of

the moment – and that was what made it so sexy: it was so hidden, so well disguised in sound and yet crisp in my imagination. That's what – and maybe now I'm being romantic – that's what I'm looking out for. The actual sensation I feel when I have an encounter like that. Not the factual melody of something, but my own sort of measuring of the space, and feeling my own distance to a sound.

LEA: Video games do this very well. The actions that trigger sound effects are measured mathematically. They are real. The amplitude is adjusted if something explodes in closer proximity to you, masking other sounds. It's extraordinary. Maybe it has something to do with the avatar being present in this fantasy soundscape and landscape that you're in – participating in the fantasy of it, I mean, given agency.

ALG: There has been such an influx of ASMR in recent years. I feel I can relate to it, but then again when I hear it back in music releases, it feels a bit like ticking a box to me. Does it really only trigger something because it shouts it? Or whispers it, in this case.

LEA: Isn't it just a fascination with sounds that you wouldn't normally hear? They would be part of a whole arrangement of sounds, like those you described in the *Hinterhof*, for example. Or what you encounter in a film through mise en scène. It's predominantly an audio experience in my judgement, rather than anything else. There's so much going on that is opaque because of the distance, some elements are louder than others, or certain sounds deteriorate, etc. The thing with ASMR is different, because it would also be part of such

scenes, but you would never hear them; so the fascination with it is more like a fascination with what we are missing out on. Focusing our ears on a tiny little action – which we wouldn't otherwise hear because it's mired in a sonic envelope of everything else – is very tantalising. It frees us from the bodies we live in.

ALG: Well, the theory was also that it just triggers certain kinds of people who have a physical reaction to it. I guess everyone does in a way, but in a much more toned-down version.

LEA: Perhaps it's a neurological phenomenon like synaesthesia. Perhaps not everyone's brain is able to engage or experience it in this way and it's just shut off or you need to practise it. That's also true of tonality: you can train yourself to pitch, even if you consider yourself tone-deaf – which isn't actually a thing, I read somewhere.

ALG: I'm just bringing it up because we were talking about field recordings and my idea to mimic something through a sound metaphor – without using the same technical possibilities, in other words.

Maybe Robert Ashley is a good reference, again. Something specific about his work is that he did a lot of different things – operas, tv shows, recordings. Something that kind of interests me is that his protagonists always seem slightly absent in their expression. There's never an idea of acting in a classical way, in the sense of embodying a character through mimesis. They're all hollow in a way, but not superficial or shallow; you can get beyond the surface. The actors always talk in this very automatic, increasingly computer-generated humanity... (His most famous record is called *Automatic Writing*).

LEA: It's that the words of thought become the instrument. Maybe the hollowness is what it would actually feel like to hear the thoughts of others – because they need to be embodied to feel physical?

ALG: I try to use that a lot in my plays, or in terms of how I speak in performances. If I get feedback, people often ask me how I record vocals. I have the cheapest microphones, to be honest. I don't want to say it to people, but there's something about my mannerisms, or a tense, mellow flow of words that suggests a sort of closeness or intimacy, that is just borrowed. Maybe that is something that ASMR does too: it zooms you a bit closer into a conversation, which in this context would feel much more private than it actually is.

LEA: I see what you mean when you bring up your own delivery. It creates the sense that it isn't actually even spoken. As if it's being heard through ESP, even. The thoughts are not being read by a reader but read from the mind of a person that the reader is talking about. I can see how that would relate to ASMR. Like 'invisible sound'.

ALG: Or 'audible inaudible sound', even. I used to go to the doctor with my mum. I remember experiencing the situation of being in a waiting room the first time, which always occurs in my plays too. The people from my town, whom I knew from other contexts, would suddenly stop speaking in their normal way. They would sit really close to each other and gradually mute their voices, in order to hide the delicacy of their stories from the others in the waiting room. You couldn't hear them, but you could hear outlines of these voices and fill in the blanks of what they actually said. This resonates

with me a lot, stripping away information up to the point where it merges with the background. If you look close enough though, it creates an intimacy. Something which I feel isn't being used a lot, as a technique. This ASMR phenomenon made people suddenly understand the resolution of sounds and the possibility to zoom in on them.

LEA: Those whispers you describe, they become so thick that the whole situation feels like it is a living and breathing organism. Yes, of course it is alive, because they're actual people who are waiting; they're alive and they're whispering. But I mean the 'whole' thing as one space just breathing. All of these barely audible artifacts that just hang there and make it thicker and thicker.

ALG: Think about it, isn't whispering actually the most forceful tool to get someone's attention?

LEA: (*laughs*) Yes, and it's also in such a high pitch that it's actually louder than most sounds. Of course, nobody notices the obvious. If you're just in a room talking about intimate stuff with someone, there's a high probability no one is paying attention. If you're whispering, everybody is like, 'what's that'?

 I think we are taught to think we can or should control our vocal impact. This is something of an illusion. We don't always have control; fear makes us bark; concern can be heard as growling. Whispering often comes with masking. You don't want someone to know that you're angry with them, or you're judging them, talking under your breath, trying not to show you are on the verge of tears. Yet you hardly ever get away with it. I don't, anyway.

ALG: This monotone way of speaking 'in parts' is also what you did in the *Disintegration* piece: in a controlled sound environment the acting would push listeners into too many directions, so you relied on something that maintained a certain flow without being too emotional.

 Did you know that *Private Parts* by Robert Ashley is conceived as a two-sided vinyl, with 'the Park' on one side, and 'the Backyard' on the other? It's also gendered, in the sense that one describes a man and the other a woman – which also gives the title a different connotation. When I started the Ruisdael Stipend project, I wanted to do a cover version of it and get rid of the pronouns (he uses a lot of descriptive sentences like "She takes her…"). I've always thought that it's exposing to tell a story in writing or out loud and strip away the parts that you would rely on the way you do information in movies, for example. Do you really need to know this specific information, or could you actually circumnavigate it, and by doing so also reveal that sometimes you are relying on assumptions in gathering these bits of information? Notably in terms of gender, for example. I'm not arguing for non-specificness in general; sometimes I think it is really important for us to understand a perspective through character, gender, etc. But when he renders it in sound, Ashley doesn't give us specific characters.

 I was just wondering how it would sound if we didn't get these indications in the first place and had to 'extend' our listening by learning to fill in the gaps. More in the sense of listening in on how much of that binary conception of things is already present in us. Do you know what I mean?

LEA: I think I do – but that was in 1978,

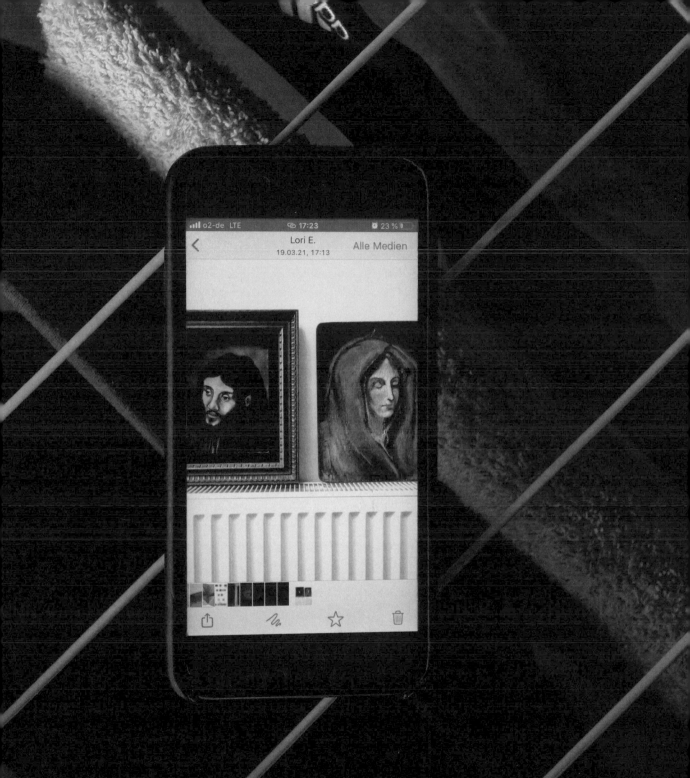

Radiator in Saints, 2021

Lori E. Allen: *My Grandma Bucia, Helen Hedwig Bazaan Boenker, painted many Marys in addition to having one, my mom. This one is from 1970, the year my older sister was born. The Jesus was painted by her prison penpal. It was a gift to her from him. I never knew his name but my Grandma used an alias when pen-palling – Claire Banks.* (Photo: Deborah Wale)

wasn't it? I think the gendering, and titling it with each side, helps you to navigate your way through the content of the prose. A backyard being a 'private part' for a woman makes a lot of sense for most people, within the reality of 1970s gender politics. The woman's space as the house, which holds all the opportunity available to her. The backyard would be the edge of that. When it mentions the horizon where the sky meets the grass it says that she doesn't even question it's a line, and she thinks of it as an invitation: to cross the boundary – of character, of construct, of a life inherited.

On the YouTube link you sent me somebody commented that it was a re-digestion of Ecclesiastes – the most existential chapter of the bible:

What do people gain from all their labours at which they toil under the sun? Generations come and generations go, but the earth remains forever. (Eccles.1:3–4)

When taken together, those two bits lead me to understand the piece as being about domesticity – a dictated relationship with faith, obedience.

ALG: I really just wanted to follow the simple idea of seeing what it does if you take away the pronouns. I think that is the cool thing about writing a story: we can specifically assign or not assign something to characterise a person. I'm also not even sure if it is a good thing to leave pronouns out, but I think I was aiming to see what remains if you do.

In my head, it sounds great if I tell a story from someone's perspective without giving people an idea of what gender that person is.

LEA: Because the second person singular is then a blank canvas which you can fill with your own knowledge of selfhood.

ALG: You would have to employ other ways of figuring out what relates to which gender, or a spectrum. It's a question I'm asking myself and I wasn't sure if doing that to the Ashley piece was a good idea in the end. It's a great piece, I love it. I could listen to it forever; I always find something new in it. ██████████████████████████ ██████████████████████████ ████████████████████████ I was so puzzled. Do you know *Matmos*? They performed the piece at the Barbican a while ago. And when I read that, I thought there was someone being open to the idea of a younger generation re-performing it. What's interesting about Ashley is that it's time-based media, but lots of it was of course performed live, so it became a quite disconnected body of work, contrary to other composers who are mainly remembered through their recordings. There have been a few re-releases recently and I'm sure he is quite an influential composer for a limited number of people. ████████████████████ the work to circulate widely, which is sad. I mean, we've witnessed how the internet has erased a lot of music that didn't have the infrastructure to licence etc.

LEA: What was the reason?

ALG: ████████████ very angry. Lots of

exclamation marks. I was so shocked, why wouldn't you? My idea also originated in thinking about what notation means for our generation. We're so used to the availability of music that there's almost no contemporary engagement with notation, except in classical music. So, I thought about canon, and about making something visible again through a cover, as in a rendition of a work. I understand I am not an important figure. But I generally believe that people should make these kinds of judgements in a horizontal way and not vertically, because you'll never know for certain what will come out of such a work. Just to say, when I first heard it, I did hear it because someone had uploaded it to YouTube. So I just stopped there. I get that you have to ask for permission, but I also like to spark a conversation about such things. Can this be done? No!!!

LEA: It's so mean-spirited. It is out there, and we are digesting it. This is of course a larger discussion about copyright. I don't know if this is generational, it could be, because when I was a kid, like I've said, my biggest influence was *Negativland* and that plundering of stuff that we are forced to digest. It's so important to be easy about that. It's in our minds, we have the right to process it. And we might choose to process it in different ways. If it's just about this banal question about rights and money and archiving, surely there could be a legal structure that could address that. There are highly sophisticated legal structures for insurance, but copyright law is a dead space. It fails to address the unwanted impact of media culture on personal lives, if/when people are penalised for attempting to interact with a published work. This affects everyone, I don't even want to say

artist or creator; anyone who's just an audience to the culture that they live in – which is every one of us.

ALG: Ashley edited a book where he held interviews with other composers. Ironically, the title is *Music with Roots in the Aether.*

LEA: Yes.

ALG: Before, we talked about releasing music that is subsequently no longer yours in a symbolic, not legal way.
 There is a chance that in the realm of these 1980s composers that emerged out of a subculture rather than academic environments, some got really famous – Laurie Anderson, Brian Eno, Steve Reich etc. I suppose it was a very vivid music scene. Steve Reich is so known for these repetitive figures, but I'm sure if you look at it really closely, you'll find a lot of people doing it at that time.

LEA: Absolutely.

ALG: I think that some people who sort of 'survived' that scene and saw others become really famous, or have their music in an Apple ad, might also have ended up being quite defensive about their work (or the work they represent). And so they might not be as open as our generation when it comes to the whole idea of sharing, and the economy that sharing produces. But to come back to Ashley: maybe he didn't want his work to remain performed, which is irritating – at least for an artist whose practice revolved around ideas of broadcasting, transmitting, sending and receiving.

LEA: It destroys all these fantasies you have about what an artistic community is. Not the one you're engaged with contemporarily, but more as a whole. That there is timelessness to it. Why would you?

ALG: Any musician should just shrug. How would a Mozart piece have survived if people hadn't played it?

LEA: I can't tell you how many times I have heard a film use Mozart's requiem or Klaus Nomi's *Cold Song*. They're everywhere. Whenever I hear it, I'm always thinking how great that is. I know it's overused, but I think, "Oh, that's on your radar too?" It means so much to me, I am so moved by these pieces. I love it when other people feel that they also want to include them in their work. I think it's the ultimate compliment.

ALG: Canonised work, you mean?

LEA: Yes.

ALG: I do have that with that famous *Carmen* piece by Bizet. It always gets me.

LEA: Or the Blue Danube.

ALG: Oh my, I need some sugar, cookies.

Materials discussed:
De Rodrigo (Rodrigo Muñoz Ballester), *Manuel* (Madrid: La Luna de Madrid/Ediciones Libertarias, 1985).
Armin Lorenz Gerold, *Scaffold Eyes*, spoken by Miriam Stoney, Doireann O'Malley and Armin Lorenz Gerold, The Tapeworm/Wormhole, WHO#11, 2019, compact disc.
W.G. Sebald, *The Rings of Saturn* (New York: New Directions, 1997).
Robert Ashley, *Private Parts*, performed by Robert Ashley and Robert Sheff, recorded at The Recording Studio, Center for Contemporary Music, Mills College (Oakland, CA), Lovely Music LML 1001, 1978, 33 rpm.
Rachel Pimm and Lori E. Allen, *Disintegration*, performed at Whitechapel Gallery, London, 7 March 2019, https://soundcloud.com/whitechapel-gallery/disintegration-rachel-pimm-at-whitechapel-gallery
Robert Ashley, ed., *Music with roots in the aether* (Cologne: MusikTexte, 2000).
Negativland, *U2*. SST Records SST 272, 1991, 45 rpm.

Wirefoxterrier, *Radio Pristina*, 2020
Record cover showing the National Library of Kosovo in Pristina

Armin Lorenz Gerold (b. 1981, Graz, Austria) is an artist and composer based in Berlin. Working across a multitude of media, Gerold primarily focuses on voice and sound, making audio plays, live-performances, broadcasts and installations.

His sound installations and performances have been presented at: mint, Stockholm, Sweden (2019); fluent, Santander, Spain (2019); Kunstverein Bielefeld, Germany (2019, with Beatriz Olabarrieta); LambdaLambdaLambda, Pristina, Kosovo (2018); Between Bridges, Berlin, Germany (2018); and KW Berlin, Germany (2017), among others.

In August 2021, Gerold will premiere a performative sound installation at Halle für Kunst Steiermark in Graz, Austria.

Between 2016 and 2018 Gerold scored and sound designed the *Prototypes* film installation series by Irish artist Doireann O'Malley, which has been shown in different formats, formats at Hugh Lane Gallery, Dublin, Ireland (2018) and mumok, Vienna, Austria (2018), among others. In 2019, *Prototypes* was conceived in a 5.1 sound installation at the Gothenburg Biennale for Contemporary Art, Sweden.

Gerold's audio plays have been released and broadcast in a variety of formats. *#ellipticallife* (2015) was aired at Berlin Community Radio. *Scaffold Eyes* (2017) was released as a limited edition CD by the London-based label The Wormhole. In May 2021, Gerold scored *Another Goodbye*, an audio play performance by Adie Mueller directed by Peader Kirk, which premiered at The Place theatre in Bedford, UK.

Gerold co-edited and designed the publications *AIDS. A Reader* (Akademie der bildenden Künste Wien, Vienna, 2008), *Wahre Koenige* (self-released, 2011, co-ed. with Manfred Hubmann) and *Hotel Charleroi Annexe* (2013) with Daavid Moertl (Ed. Georg Petermichl/Antoine Turillon), among others.

Armin Lorenz Gerold releases pop music and also performs under the moniker of Wirefoxterrier.

In May 2020, Wirefoxterrier released the debut EP *Radio Pristina*. Before the release of the EP, the singles *Episode VI, Sex (Play and being played)* and *Episode IV, Dad is gonna be mad at me* were featured on the soundtrack of the LGBT teen drama *SKAM Italia* (Netflix, 2020)

In December 2020, Wirefoxterrier released the single *Call me Babes*. The music video was directed by Robin Plus with typography by Enver Hadjijaj.

Wirefoxterrier hast performed live at: Kunsthalle Wien, Vienna, Austria (2014); Suedblock, Berlin, Germany (2015); rhiz, Vienna, Austria (2016); KW Berlin (with Lonely Boys), Berlin, Germany, (2017); and Konsthal C, Stockholm, Sweden, (2020).

The artist's sounds and music have been included in numerous podcasts, mixtapes, soundtracks, campaigns and sound installations.

In 2017 Gerold was a participant of Berlin Program for Artists. In 2020 he was awarded the Ruisdael Stipend.

Lori E. Allen (b. 1975, St. Louis, Missouri) works in experimental composition and auto-digested cultural media. Drawing from a background in archaeology, Allen interprets audio-visual landscapes through a process of 'reverse excavation', dislodging the bodiless objects generated between broadcast, reception, and thought; body and consciousness; narrative and material culture. These 'objects', material and immaterial, are both the formal and conceptual media to which Allen composes her syncretic audiovisual compositions. Collaborative and solo work includes performance and or exhibition at: Tate South Tanks, London, UK (2017); Whitechapel Gallery, London, UK (2019, 2020); Chisenhale Gallery, London, UK (2015); London Science Museum, London, UK (2019); and Glasgow CCA, UK (2016). She is published collaboratively under *Tears|OV* on Tapeworm (2016, 2018, 2019), the Wormhole (2019), Bloxham Tapes (2021). A new project is forthcoming on Trouble In Mind Records.

Anna Barfuss (b. 1980, Vienna, Austria) works within the fields of fine art and theory, with a focus on video, installation, sound and photography. Her artistic practice draws on the experiences of everyday culture and transient lifestyles, memory and interpersonal relationships. She currently works with fabrics and materials that through their functionality refer to the body and initiate questions around possible acts, intimacy, therapy and poetic tools.

In her theoretical research Anna Barfuss aims to conceptualise the body, subjectivity and interconnectedness in relation to digital culture. She writes essays and reviews that have been published in cultural magazines (*Camera Austria International*, *Springerin*) and catalogues. Barfuss has also curated exhibitions in various formats, mainly exploring moving images and sound in relation to economic and affective spaces, as in *Erholungsgebiet Industriegebiet* at Fluc, Vienna (2015). Screenings and performative lectures include: Longtang, Zurich (2019); *Tangente* at ArtReview Bar, London (2017); *This could be in focus!*, Austrian Cultural Forum, London (2017); and *How far to open up?*, Forum Stadtpark, Graz (2017).

Alejandro Alonso Díaz (b. 1990, Santander, Spain) is a curator and researcher who explores the metabolic encounters between natural, social and poetic structures of knowledge, investigating structural ecologies and their impact on society.

He has curated several exhibitions and is currently involved with the ecological research platform *Matter in Flux*. Since 2016, Díaz directs *fluent*, a para–institution in Santander, Spain, dedicated to imagining new socio-natural ontologies through contemporary art. His writings on art, moving image and nature have been published in major publications such as *Frieze*, *Mousse* and *Terremoto* and numerous exhibition catalogs.

Shahin Zarinbal (b. 1985, Wuppertal, Germany) is a writer, producer and gallerist based in Berlin and Cologne. Since 2010, he has been involved in various publishing and curatorial projects. In 2019, he co-founded Zarinbal Khoshbakht in Cologne, where he has presented artists such as Mark Barker, Andrey Bogush, Behrang Karimi, Sinaida Michalskaja, and Sonja Nilsson, among others.

This book is published on the occasion of the Ruisdael Stipend 2020. The Ruisdael Stipend was established in 2012 on the initiative of the artist Willem de Rooij within the framework of the international sculpture route kunstwegen.

Published and distributed by:
Mousse Publishing
Contrappunto s.r.l.
Corso di Porta Romana 63
20122, Milan–Italy

Available through:
Mousse Publishing, Milan
moussepublishing.com
DAP | Distributed Art Publishers, New York
artbook.com
Vice Versa Distribution, Berlin
viceversaartbooks.com
Les presses du réel, Dijon
lespressesdureel.com
Antenne Books, London
antennebooks.com

First edition: 2021
Printed in Germany by: Druckerei Roelofs, Lingen
Lithography by: hausstætter herstellung, Berlin
Design: Armin Lorenz Gerold
Copy-editing by: Edward Fortes, Chris Roth (Anna Barfuss)
Translations by: Shahin Zarinbal.

Edited by:
Armin Lorenz Gerold and edition kunstwegen / Städtische Galerie Nordhorn
Vechteaue 2, 48529 Nordhorn
+49 / (0)5921 / 971100
kontakt@kunstwegen.org
kunstwegen.org

ISBN 978-88-6749-476-7
€ 18 / $ 20

Armin Lorenz Gerold would like to thank everyone who made this book possible:

Dr. Thomas Niemeyer and Willem de Rooij.
Lori E. Allen, Anna Barfuss, Alejandro Alonso Díaz, Shahin Zarinbal.
Michael Amstad, Edward Fortes, Stefanie Schwarzwimmer.
Benjamin Busch, Daavid Moertl, Carlo Siegfried, Deborah Wale.
Rodrigo Múñoz Ballester, Beatriz Olabarrieta.

Further thanks for the ongoing support of my work:

Mark Barker, Carmen Brunner, Jennifer Hope Davy, Maurin Dietrich, Emily Fahlén,
Enver Hadzijaj, Asrin Haidari, Doireann O'Malley, Philip Marshall, Cathrin Mayer,
Sinaida Michalskaja, Mathis Anders Pedersen, Robin Plus, Zarah Rehr, Barbara Urbanic,
Wolfgang Tillmans.

An audiovisual version of *Manuel or A Hint of Evil* can be accessed through the QR code below:

The Ruisdael Stipend is funded by:

 Gefördert durch die Emsländische Landschaft e.V. für die Landkreise Emsland und Grafschaft Bentheim mit Mitteln des Landes Niedersachsen

 Nordhorn
Städtische Galerie

 kunstwegen •••••

 die grafschaft
Landkreis Grafschaft Bentheim